Michelangelo

Text by Marco Bussagli

GIUNTI

Graphic design: Giovanni Breschi

On the cover: a detail
from the *David* (1501-1504),
marble,
Florence, Accademia Gallery

Translated by Catherine Frost
Editor: Augusta Tosone

ISBN 88-090-1591-6

© 2000
Giunti Gruppo Editoriale, Florence

Contents

The early years

Sculptor, painter, architect and poet, Michelangelo Buonarroti was born in Caprese, a little town in the Tiber Valley, «on the sixth day of the month of March 1475, four hours before dawn», as reported by his biographer, pupil and friend Ascanio Condivi. According to the wishes of his father Ludovico – a descendent of the noble family of Canossa, who held the position of Magistrate of the towns of Chiusi and Caprese – Michelangelo was destined to a career in literature.

Having moved to Settignano at the conclusion of his term of office, Ludovico – after the death of his wife Francesca di Neri di Miniato del Sera, in 1481 – enrolled the future artist's brothers in the Wool and Silk Guild, and sent Michelangelo to the school run by Francesco da Urbino, a grammar teacher. The keen intelligence of the six-year old boy led to high hopes for him but, as reported by Giorgio Vasari, biographer and admirer of Michelangelo, «all the time he could, he secretly consumed in drawing, being for that by his father and by his older brothers scolded and sometimes beaten, believing perhaps that exercising that talent unknown to them was a low thing not worthy of their ancient name». From his father's point of view, the passage of time brought no improvement. Michelangelo became close friends with Francesco Granacci, a boy who like himself frequented the workshop of Domenico Ghirlandaio and who, according to Vasari, gave the young genius the master's drawings every day so that he could copy them. And so, as Vasari continues, Messer Ludovico «not being able to deviate the youth from drawing waited no longer [...] he resolved [...] to apprentice him to Domenico Ghirlandaio». When Michelangelo entered the shop of the Florentine painter he was twelve years old, but his apprenticeship was

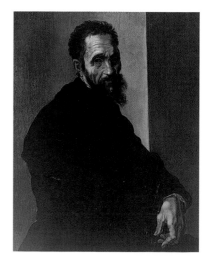

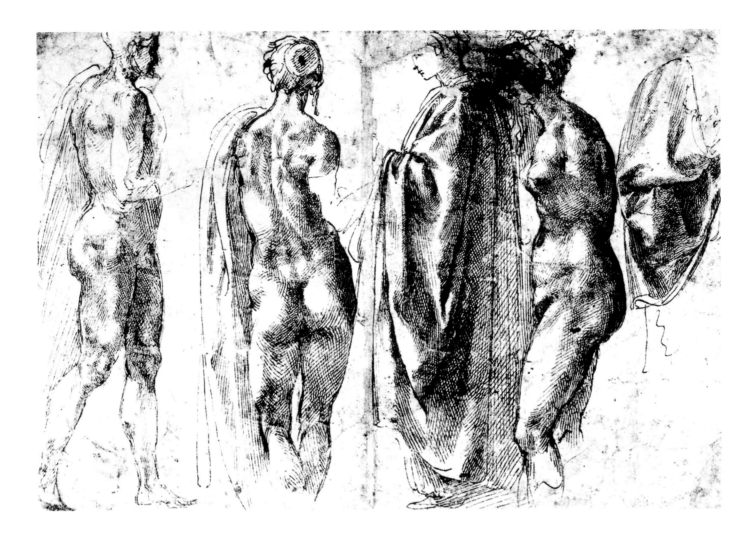

On the opposite page, Jacopino del Conte, *Portrait of Michelangelo* (c. 1550-1560, Florence, Casa Buonarroti). Above, five studies by Michelangelo which show how the young artist was already well familiar with ancient statuary (1489-1501, Chantilly, Musée Condé).

shorter than usual also because the master quickly realized how talented he was. Unfortunately, little remains of Michelangelo's artistic production from this period, during which he must have been engaged chiefly in copying the works of the great 15th century masters, not the Italians ones alone. A famous anecdote reported by both Condivi and Vasari states that the young apprentice copied in pen-and-ink a print by the German Martin Schongauer portraying the *Temptation of St. Anthony*. No trace has remained of Michelangelo's drawing, but a copy of the print by the German master exists today in the Musée du Petit Palais of Paris. This work earned him a «great name», relates Vasari, so that he «copied again works by various old masters so similar that they could not be distinguished, since by dyeing them and aging them with smoke and various other things [...] he made them seem old, and comparing them with the originals it was impossible to distinguish one from another». Several sheets documenting this activity of the young artist have survived, such as the famous one in the Louvre with a copy of the two figures painted by Giotto on the left in the great fresco of the *Ascension of*

St. John the Evangelist in the Peruzzi Chapel in Santa Croce at Florence. Dated by critics between 1488 and 1496, Michelangelo's copy of Giotto's work immediately reveals the artist's interest in the volume and plasticity of forms, while simultaneously demonstrating that Michelangelo had perfectly assimilated the technique of pen-and-ink hatching taught by Ghirlandaio. It is unsurprising that the choice of subjects can be considered programmatic, in view of the fact that Michelangelo copied not only Giotto but also Masaccio. From the Brancacci Chapel he copied the monumental figure of Peter stretching out his arm to pay tribute to the tax collector, as well as the figures of the First Parents in the *Expulsion of Adam and Eve*. But these were not merely pedestrian copies. Adopting the same subjects, Michelangelo personalized them with his unmistakable style. It could even be said that he "improved" on them at times by correcting errors. In Michelangelo's drawing of Adam for instance, the attachment of the left leg is no longer erroneous, the position of the right shoulder is correct in respect to the line of the back and the entire figure anticipates the titanic anatomy that was to distinguish the masterpieces of the genius from Caprese.

The reputation of the young artist achieved through drawings such as these opened for him the doors of what, for the sake of brevity, may be called the "Medicean Academy". At that time, in fact, Lorenzo de' Medici, lord of Florence, decided to open the great garden of the Monastery of San Marco in Via Larga to young artists, where he kept a precious collection of antique sculptures and gemstones. It was Lorenzo's intention to create a real school to promote new talent so that the art of Florence would have no rival. Bertoldo di Giovanni, a sculptor and medal-maker who had been a pupil of the great Donatello, was custodian of the collections, acting also as tutor. The most important artists in Florence indicated to him, from among the boys in their shops, those who were sufficiently talented to enter the school established by «the Magnificent Lorenzo», as his contemporaries called him. Domenico Ghirlandaio chose from among his apprentices Francesco Granacci and Michelangelo Buonarroti. The intellectual and artistic gifts of the latter soon won him a special place in the school. Condivi reports that the Magnificent «had given Michelangelo a good room in his own home, procuring him all of the comforts he desired and treating him like a son».

But frequenting the Medici home meant even more for Miche-

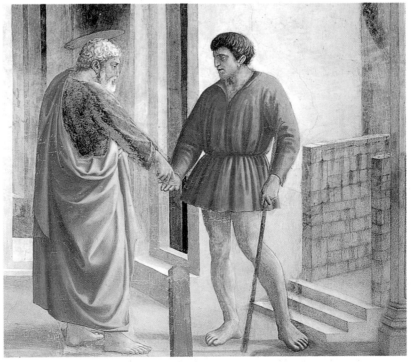

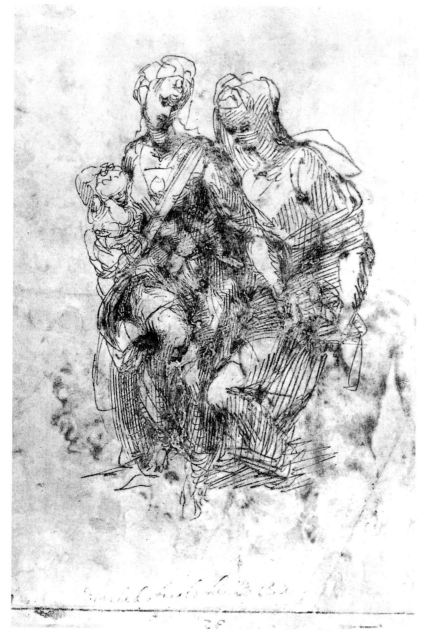

MICHELANGELO
AND LEONARDO
At left,
Madonna
and Child
with Saint Anne
(c. 1501-1502,
Oxford,
Ashmolean
Museum),
copy of
Leonardo's
cartoon for

The Virgin
with Saint Anne,
the Child
and the Infant
St. John
(below,
c. 1497,
London,
National Gallery).

langelo – the chance to know all of those intellectuals who rotated around the court and the dining table of the lord of Florence. And as Condivi reports, «Michelangelo frequently had the honor of sitting closer to Lorenzo than his own children and other illustrious persons who were always numerous in that home».

Michelangelo's mind was now opened to philosophy and letters, as well as to art. Not by chance, tradition holds that the poet Angelo Poliziano suggested to the young artist that he create a work based on the myth of the battle between the Centaurs and the Lapiths, after having told him the story. That sculpture has come down to us: it is the *Battle of the Centaurs* in Casa Buonarroti, sculpted slightly before the death of Lorenzo de' Medici.

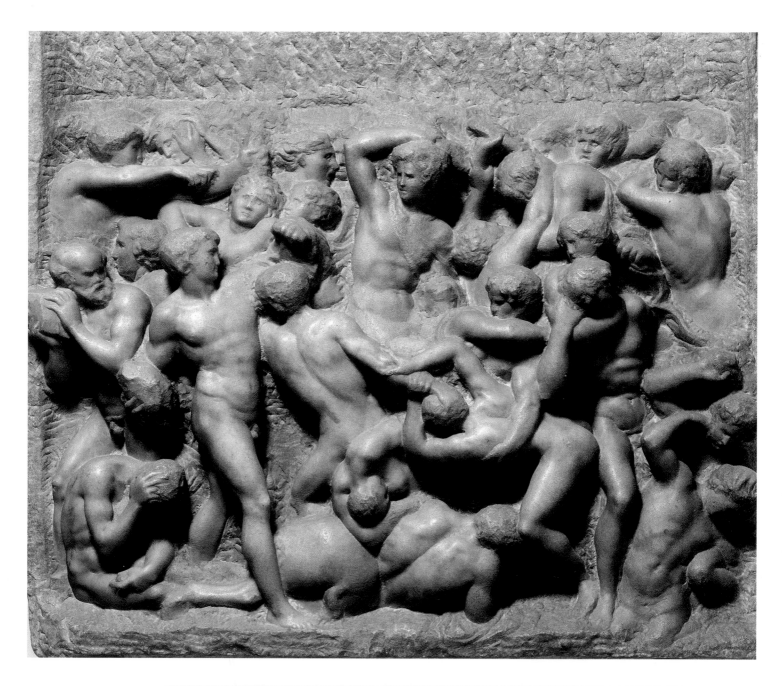

MYTH AND ART
Above, the
*Battle
of the Centaurs*
(c. 1492,
Florence,
Casa Buonarroti).
Right,
Bertoldo di Giovanni,
Battle
(c. 1480,
Florence,
Bargello).

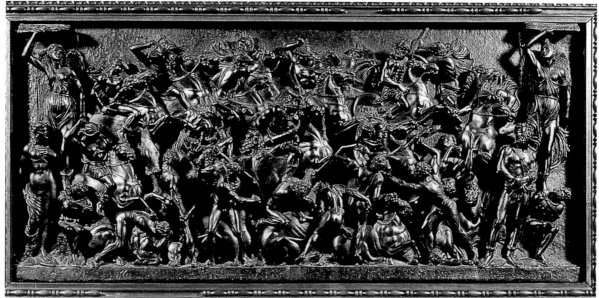

 # Michelangelo
the sculptor

That Michelangelo considered sculpture and not painting the finest means of expression and creation is shown by an anecdote related by Vasari. The biographer states that the artist's father had sent the baby Michelangelo to a wet-nurse in Settignano whose husband was a stone-cutter. The artist always considered this to be a sign of his destiny and one day, in a confidential moment, he confessed to his friend that what little of genius he possessed had come to him from being born in a land of artists such as Arezzo, but also from having sucked «from the milk of my nurse the scalpels and hammer with which I make my figures».

Moreover, the artist's very first works were sculptures: drawings served as studies, while sculpture was the means through which he gave concrete form to his ideas. Undoubtedly, it was the old Bertoldo di Giovanni who taught the young Michelangelo the secrets of Donatello's "stiacciato", the capacity for rendering immense

THE FIRST TRIALS
Opposite page,
above,
Cesare Zocchi,
*The boy Michelangelo
sculpting
the head of a Faun*
(late 19ᵗʰ
century,
Florence,
Casa Buonarroti).
Below,
Donatello,
*St. George
and the Dragon*
(pedestal for
the *St. George*,
c. 1420,
Florence,
Bargello,
formerly at
Orsanmichele).
Right,
the *Madonna
of the Stairs*
(c. 1492,
Florence,
Casa Buonarroti).

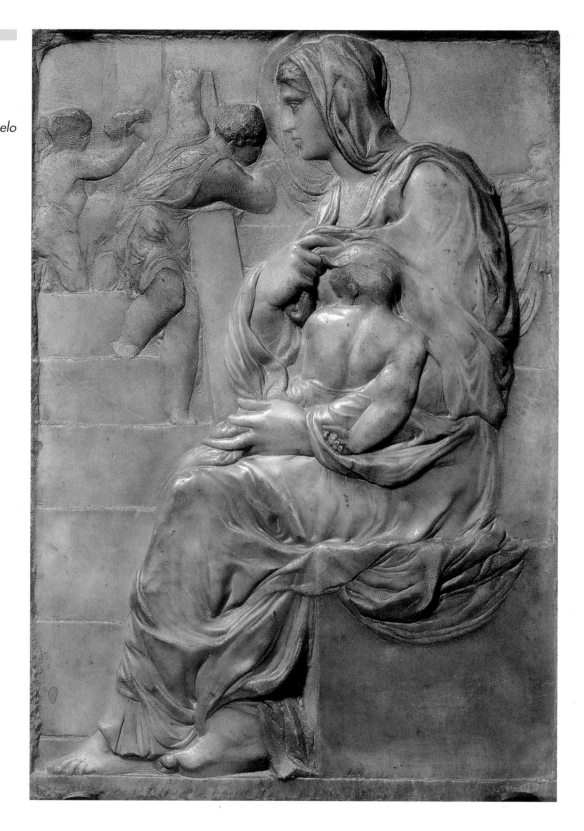

depth in a shallow slab of marble. Donatello had utilized this capacity in the marble predella of his *St. George* at Orsanmichele and in the *Banquet of Herod* for the baptismal font of the Siena Baptistery, to mention only the works most easily accessible to Michelangelo. But the reference to Donatello consisted only in adopting his technique, since in the *Madonna of the Stairs* the figure of the Virgin al-

ready anticipates the awesome power of the Sibyls in the Sistine Chapel and the abandoned posture of the Child, reminiscent of classical art, shows in its twisting motion a concept of space which is no longer that of the 15th century. To these early years belong the *Crucifix* in polychrome wood of Casa Buonarroti, carved for the Prior of Santo Spirito, as well as three small sculptures created to embellish and complete the 15th century *Arc of St. Dominic* in the Bolognese basilica dedicated to this saint. This commission was important, as was Michelangelo's stylistic development, where his knowledge of 15th century Ferrarese painting and his study of Jacopo della Quercia's reliefs for the San Petronio Gate at Bologna were put to good use. The death of Lorenzo the Magnificent and the rioting that broke out in Florence to protest the poor government of his successor Pietro de' Medici had in fact induced Michelangelo to leave the city, first for Venice, then for Bologna.

After a brief stay in Florence the artist, who had just turned twenty-one, journeyed to Rome to explain to Cardinal Riario, who had bought one of his works counterfeited as a piece of ancient sculpture (a *Sleeping Cupid*, now lost), all of his good intentions. Lodged in the Cardinal's palace, Michelangelo received from his host the first important commission of his long career, although the statue, unappreciated by Riario, was later purchased by Jacopo Galli. Influenced by the atmosphere of Rome, Michelangelo conceived the figure of a drunken Bacchus, inspired directly by ancient statuary. Of the latter, Michelangelo's work possessed the "ponderatio", or balanced distribution of forces in tension along two diagonal lines crossing in the figure (the arm that lifts the cup is balanced by the straight leg on the opposite side; the bent leg, by the slackened arm), according to a pattern that had been repeated in many variations, from Polycletus' *Lance Thrower* to the *Antinous as Bacchus* in the Naples Archeological Museum. The latter work was probably the model followed by the artist, according to recent critics.

His acquaintance with the banker Jacopo Galli procured for Michelangelo, in August 1498, the contract for what was to be one of his most famous works: the Vatican *Pietà*, the only work signed by the artist. The representation of the Virgin with her Son lying dead in her arms, of Nordic origin, was very widely diffused in Italy. Deriving from the German iconographic tradition of the *Vesperbilder* (literally, the vespers image), it was well known in the form of small wooden statues

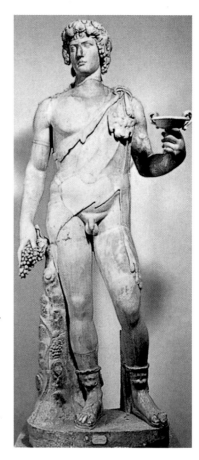

COMPARISON WITH ANTIQUITY
Below, *Antinous as Bacchus* (Roman sculpture from Imperial times, Naples, National Archaeological Museum). Opposite page, above, *Bacchus* (whole and detail; 1496-1497, Florence, Bargello). A comparison of the two works shows how the *Bacchus* of the young sculptor was clearly inspired by classic statuary.

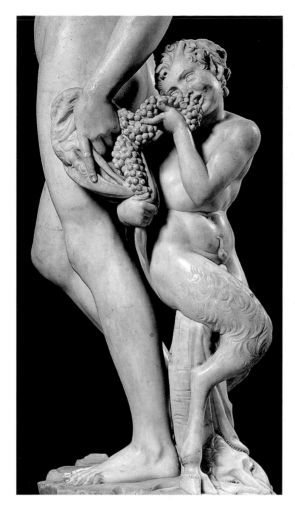

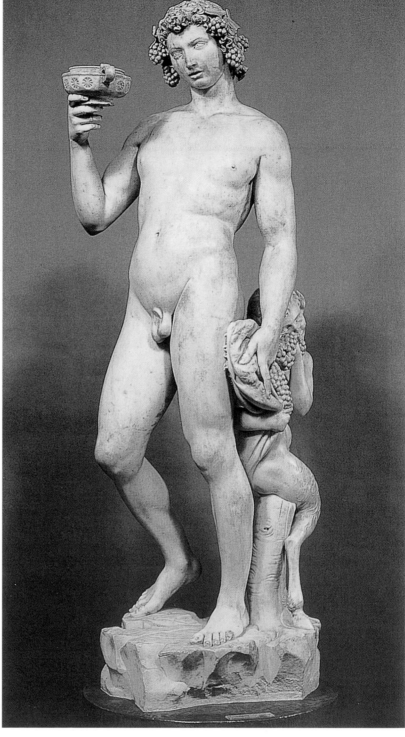

ANOTHER SOURCE
Above,
Maarten van
Heemskerck,
*The garden
of the Galli home
in Rome,*
(1532-1535).

used for devotional purposes. Michelangelo created instead a monumental version, and by portraying Mary as a young woman he emphasized the eternal value of the sentiment of pity and compassion. The beauty of this marble group definitively sanctioned the fame of the twenty-three-year old artist. The work became a model for contemporaries such as Raphael, who drew inspiration from it for his *Baglioni Altarpiece*. And the *Pietà* was to be a model even for the artists of the

next centuries: Christ's arm was copied by both Caravaggio and *David*.

The change in the political situation in Florence, with the election of Pietro Soderini as Gonfaloniere, encouraged Michelangelo to return to his native city. This inaugurated a second fruitful Florentine season which, from 1501 to 1505, was to produce masterpieces such as the *David* (see p. 48) and the splendid *Madonna and Child* commissioned by the Mouscron family of Bruges, linked to the city of Florence by commercial relationships. While it is probable that the Virgin's face shows reflections of Donatello's *Judith*, it is certain that the scheme of the work is inspired in some way by the bronze group of the *Madonna and Child* created by the same artist for the altar of the Saint at Padova. During this same period Michelangelo sculpted the *Taddei Tondo* and the *Pitti Tondo*. In the latter the rendering of the Virgin's hair clearly reveals a knowledge of Donatello's sculpture in Padova.

These two works are important also because the artist used here, for the first time, unfinished stone to produce effects of both pictorial and plastic type. Here can be seen the germ of what critics were later to call, somewhat arbitrarily, Michelangelo's "unfinished" technique, which consisted of leaving parts of the figure uncompleted to achieve a more striking effect.

In other more fragile works a boundary line must be traced between awareness of the chosen solution and the contingent need to leave the work in the state of a sketch due to the impossibility of finishing it, as in the case of the *St. Matthew*, the only statue sculpted out of the twelve commissioned by the Wool Guild. Nonetheless the *St. Matthew*, like the unfinished sculptures for the tomb of Julius II, seems almost a metaphor of the spiritual condition of man who tries to free himself from the weight of matter, and perhaps from sin.

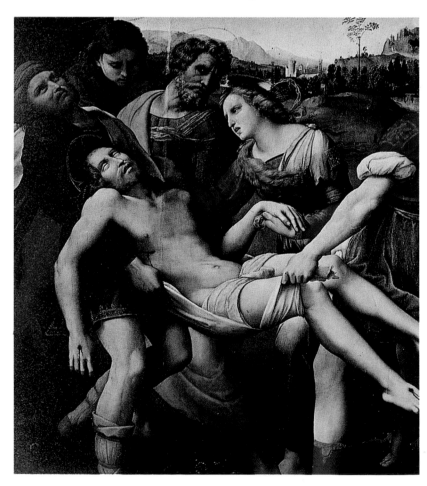

A LIFELESS BODY
Below,
Raphael,
*Carrying Christ
to the Sepulchre*
(*Baglioni
Altarpiece*)
(detail,
1507-1509,
Rome,
Borghese Gallery).
Opposite
page,
Pietà
(1498-1499,
Vatican City,
St. Peter's).

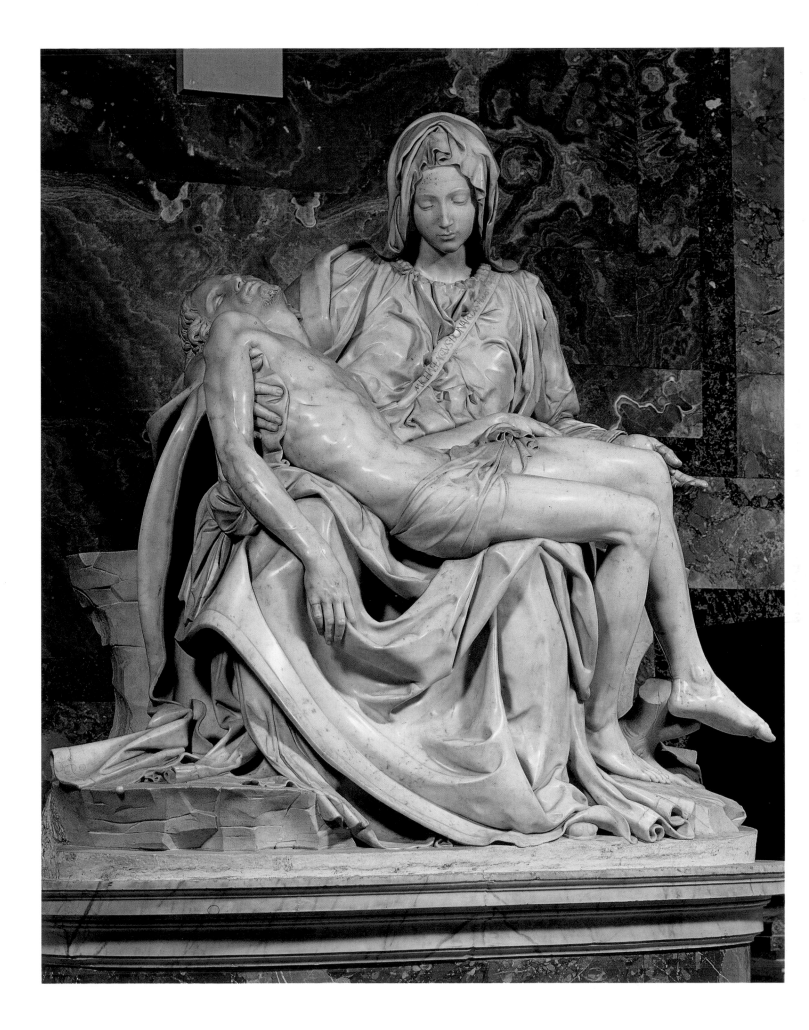

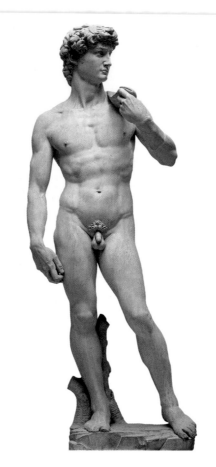

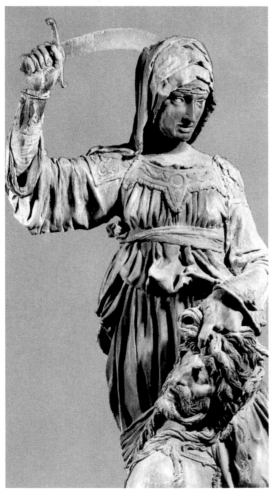

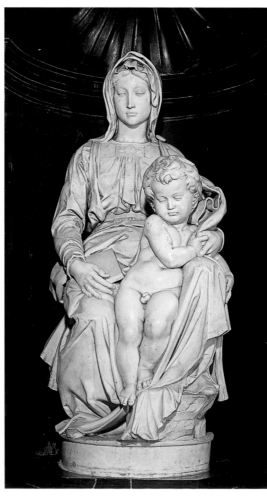

MICHELANGELO AND DONATELLO
This page, from left, Donatello, *David-Mercury* (c. 1453, Florence, Bargello); Michelangelo, *David* (1501-1504, Florence, Accademia Gallery). Below, from left: Donatello, *Judith and Holophernes* (detail, after 1461, Florence, Palazzo Vecchio); Michelangelo, *Madonna and Child* (1503-1504, Bruges, Notre-Dame). Opposite page, Michelangelo, *Pitti Tondo* (c. 1503, Florence, Bargello).

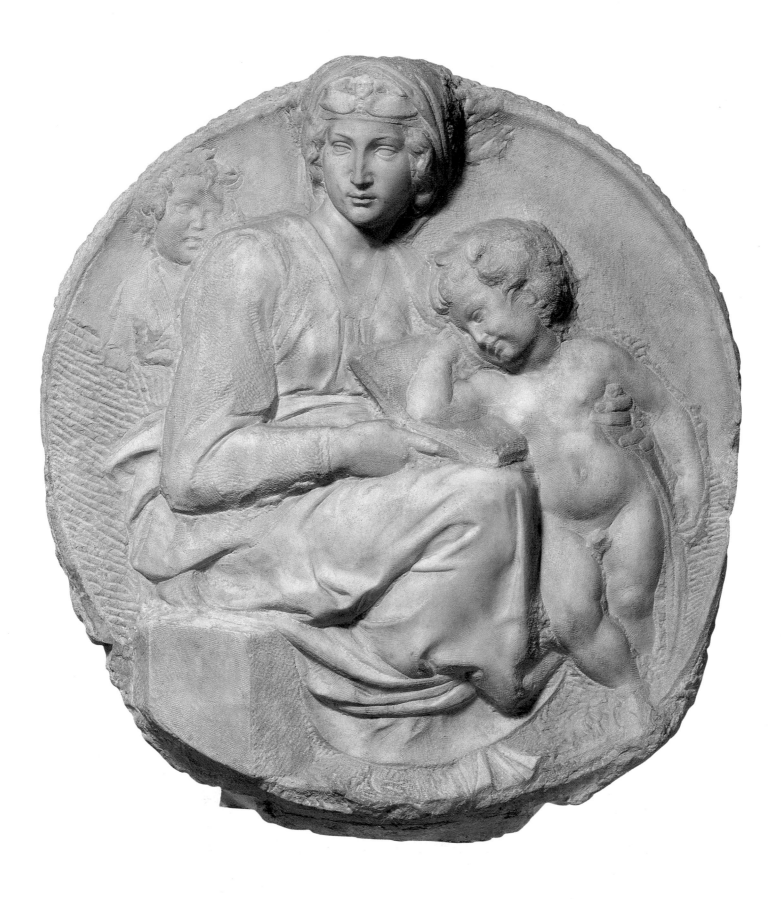

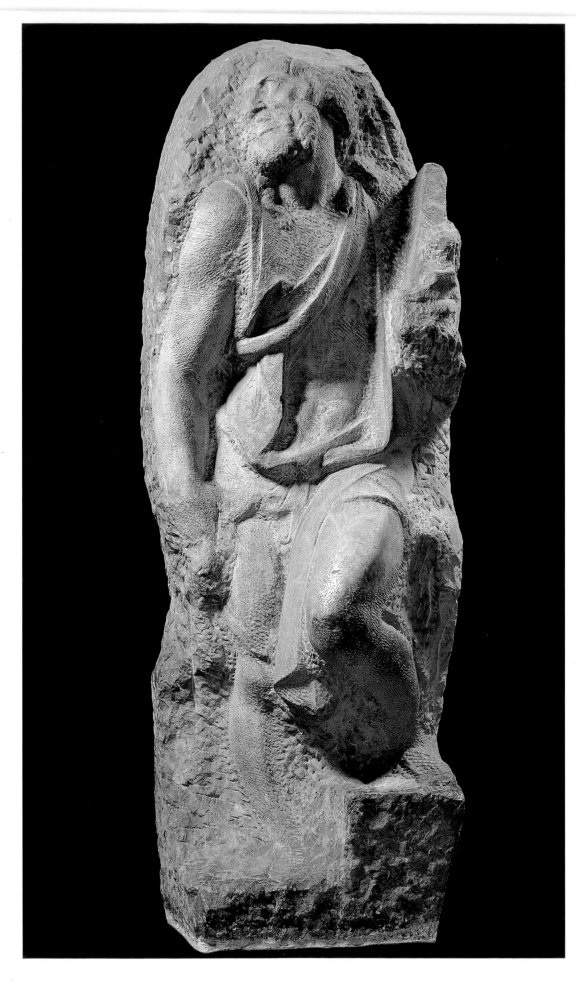

MICHELANGELO'S "UNFINISHED" This page, *St. Matthew* (1505-1506, Florence, Accademia Gallery). The value of pictorial suggestion in Michelangelo's "unfinished" was appreciated already by Vasari, but expressly for this reason the definition is to be considered conventional and evocative. When the artist utilises it purposely (that is, when there are no compelling reasons forcing the sculpture to leave a work uncompleted), in fact, the so-called "unfinished" has exactly the same aesthetic value as the finished, polished parts of the statue.

THE SLAVES

On this page:
the four *Slaves*
now in the
Accademia Gallery
in Florence.
Above, from left:
The Bearded Slave
(begun in 1519);
The Awakening Slave
(c. 1530).
Below, from left:
The Young Slave
(c. 1530);
Atlas
(c. 1530).
The four sculptures
were originally
designed
to be placed
on the mausoleum
for the *Tomb
of Julius II
della Rovere*,
in St. Peter's.
The entire project
underwent
many vicissitudes,
and was radically
reduced in size
with the passage
of time.
In the end
the mausoleum
(without the *Slaves*)
was placed in
the Church
of San Pietro
in Vincoli,
where it remains
today.

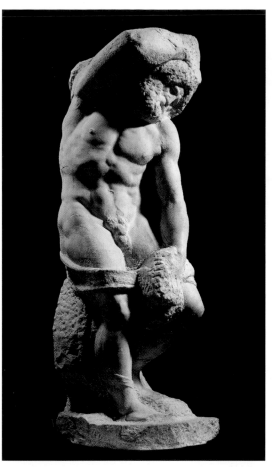

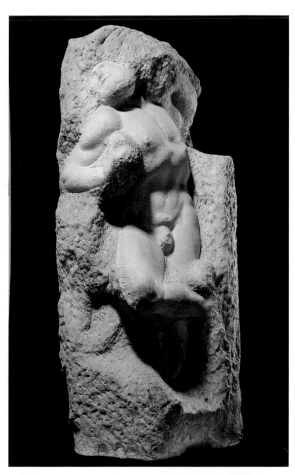

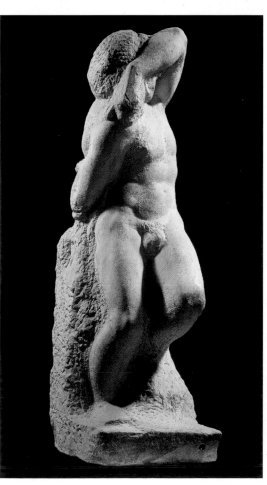

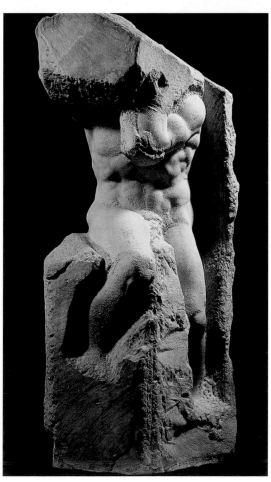

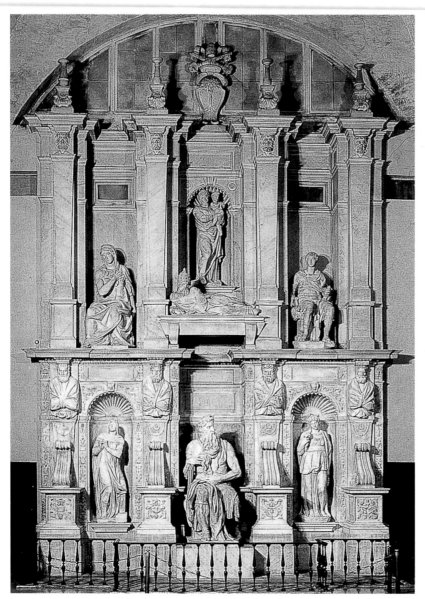

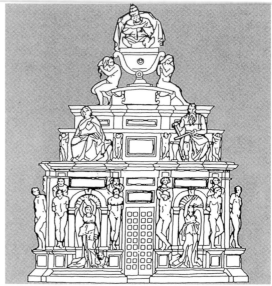

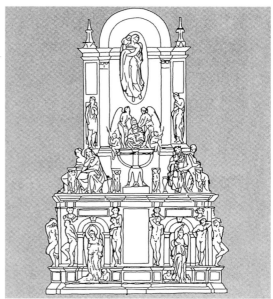

The interminable, tormented story of the tomb that Michelangelo was to have sculpted for Pope Julius II was to haunt the artist all of his life. Significantly, it was Michelangelo himself who called it the «tragedy of the tomb», summarizing the bitterness and delusion that accompanied this commission. Conceived as the culminating monument to be placed in the renovated St. Peter's in Vatican, the papal mausoleum commissioned in 1505 was finished only in 1547, but in a form much smaller than the initial project, and was placed in the Church of San Pietro in Vincoli. The artist was assisted by Raffaello da Montelupo, Maso del Bosco and Scherano da Settignano, and the only statue created entirely by the hand of the master is the *Moses* (see p. 52). And it was Julius II himself who interrupted Michelangelo in this undertaking, commissioning him to paint the ceiling of the Sistine Chapel; nor did the Pope's heirs honor the commitments that had been pledged.

A LABORIOUS PROJECT
On this page,
Tomb of Julius II
(completed in 1547,
Rome,
San Pietro in Vincoli).
In the two drawings,
from above,
the reconstructions,
according to
Charles de Tolnay,
of the first (1505)
and the second
(1513)
projects
for the *Tomb
of Julius II*.

THE MEDICI TOMBS
Tomb of Giuliano de' Medici, Duke of Nemours (whole and detail of *Day;* 1524-1531, Florence, San Lorenzo, New Sacristy, Medici Chapels).

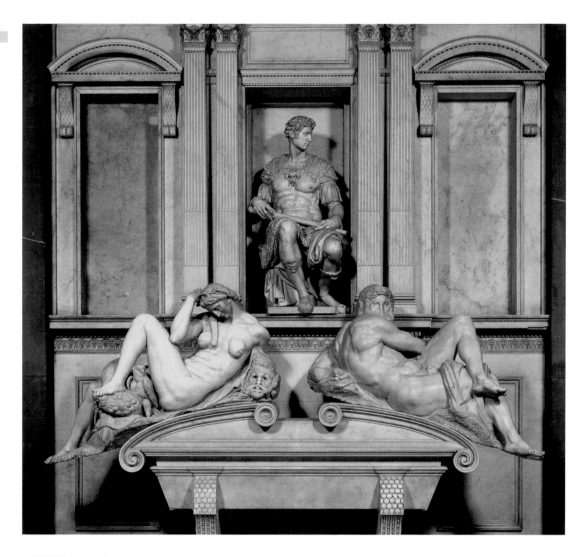

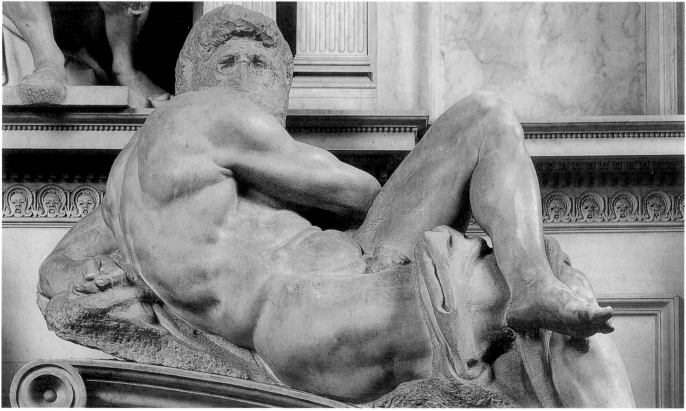

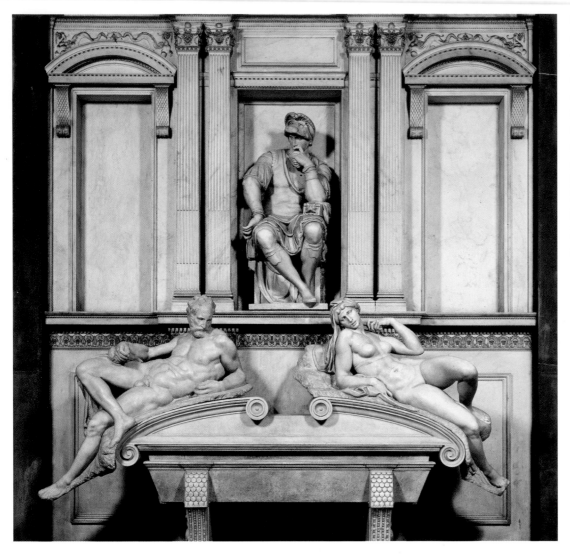

THE PRINCE'S TOMB
Tomb of Lorenzo de' Medici, Duke of Urbino (whole and detail of *Dusk* and *Dawn*; (1524-1527, Florence, San Lorenzo, New Sacristy, Medici Chapels).

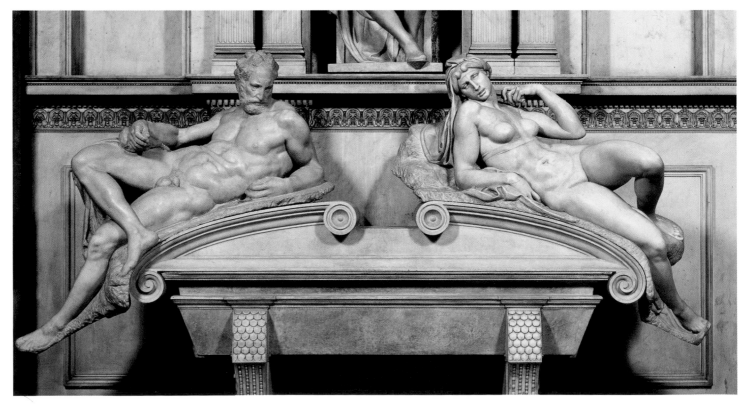

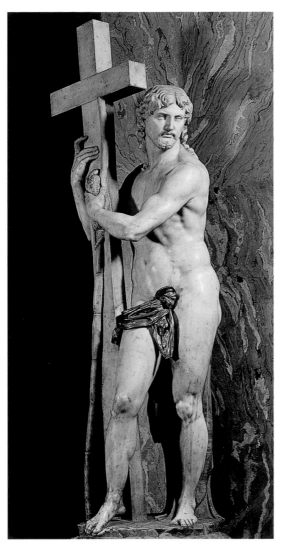
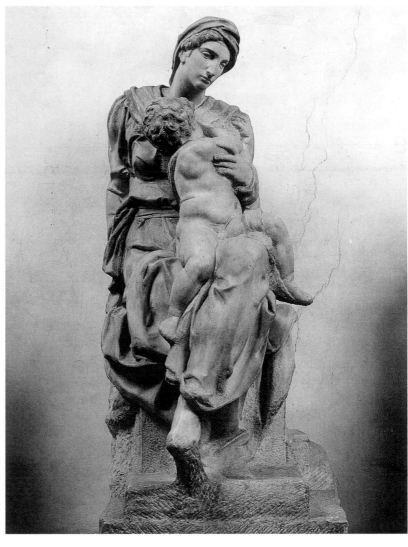

IN ROME AND FLORENCE
Above, from left,
*Christ bearing
the Cross,*
(1518-1520,
Rome, Santa Maria
sopra Minerva);
*Madonna
and Child*
(1521-1534,
Florence,
San Lorenzo,
New Sacristy,
Medici Chapels).

In spite of this, Michelangelo sculpted the splendid series of six *Slaves*, four of them unfinished. The last work he accomplished for Roman patrons during this period was the *Christ bearing the Cross* of Santa Maria sopra Minerva, completed between 1518 and 1520.

After this he became entirely absorbed in the project of the *Medici Tombs* for the New Sacristy of San Lorenzo Basilica in Florence. According to the desires of the two clients – Pope Leo X and his cousin Cardinal Giulio de' Medici, the future Clement VII – the building was to contain the tomb of Lorenzo the Magnificent and his brother Giuliano; of Giuliano II, Duke of Nemours and lord of Florence from 1512 to his death in 1516, and of Lorenzo II, Duke of Urbino and lord of Florence until 1519, the year of his early death. The tomb of the Magnificent and his brother consists of a simple base, to the right of the entrance, on which rest Michelangelo's statue of the *Madonna and Child*, begun in 1521, and those of *St. Cosmas* and *St. Damian* by Montorsoli and Raffaello da Montelupo.

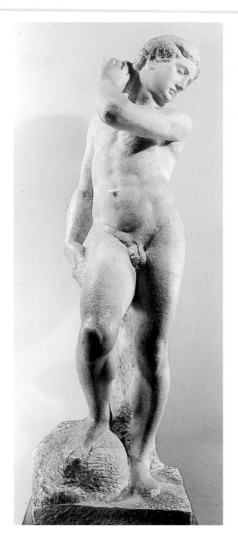

But the great innovations brought by Michelangelo to the realization of the mausoleum were the integration of the statues of the other two «Captains», as he himself called them, with the architecture which embraces them within its walls; the foregoing of any intention of portraying the deceased in realistic portraits; and the use of the "unfinished" technique for the faces of *Day* and *Dusk*. Vasari himself, moreover, realized that the "sketch" holds within itself, much more than the finished work, the sense of creative fervor. In 1534 Michelangelo left Florence for Rome. The Sacristy was practically finished and, in the meantime, the artist had sculpted the *David-Apollo* of the Bargello and the *Victory Genius*, conceived for the mausoleum of Julius II and then placed, at the suggestion of Vasari, in Palazzo Vecchio. This work was to become one of the roots of Mannerist figurative culture, as shown by Giambologna's emulation of it in his *Virtue overcoming Vice*, sculpted for Francesco I de' Medici. The last stage of Michelangelo's activity as sculptor, apart from the noble bust of *Brutus* commissioned by Cardinal Niccolò Ridolfi, was

Another David
Above,
David-Apollo
(whole and detail,
1530-1532,
Florence,
Bargello).

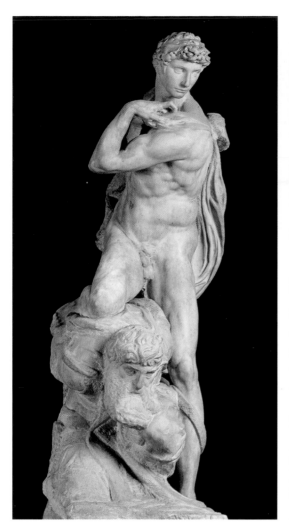 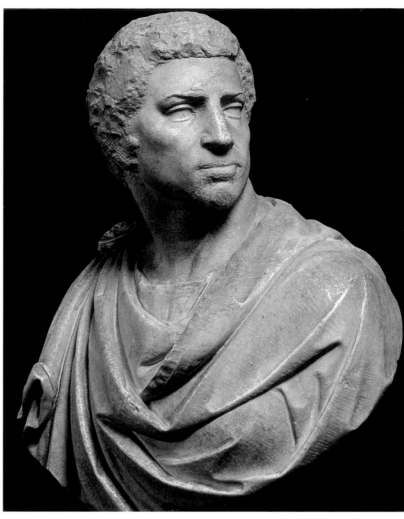

TRIALS OF STRENGTH
Above,
from left:
Victory Genius
(1532-1534,
Florence,
Palazzo Vecchio);
Brutus
(1539-1540,
Florence,
Bargello).

marked by the powerful re-emergence of a theme that had engaged the artist as a young man: that of the *Pietà*.

It was surely the feeling of approaching death to urge Michelangelo in that direction, considering that he sculpted the so-called *Bandini Pietà*, between 1550 and 1555, with the intention of having it adorn his own tomb, which he wished to have placed in Santa Maria Maggiore at Rome. Left unfinished and even damaged by Michelangelo who, eternally unsatisfied, broke Christ's arm with a hammer, the work may conceal in the features of Nicodemus (the hooded figure supporting Christ) a self-portrait of the master, although no documental evidence of this exists. As compared to the Vatican *Pietà*, Michelangelo changed the iconography, turning to the Venetian tradition of Bellini or of Mantegna where the body of Christ is offered almost as monstrance. This scheme is repeated in the so-called *Pietà from Palestrina*, which was probably only roughed out by the master and finished by a pupil, and the *Rondanini Pietà* (see p. 60), on which Michelangelo worked until his death.

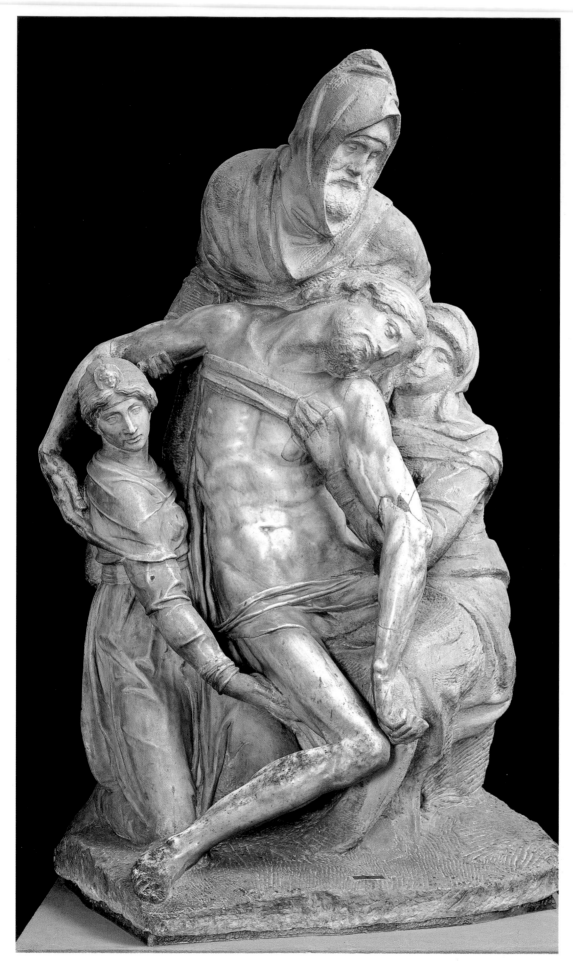

A PIETÀ FOR MICHELANGELO
On this page, the *Bandini Pietà* (1550-1555, Florence, Museo dell'Opera del Duomo). The face of the hooded figure, Nicodemus, is traditionally held to be a self-portrait of Michelangelo. On the opposite page, the *Pietà from Palestrina* (c. 1555, Florence, Accademia Gallery). The sculptor's dissatisfaction with the final aspect of the *Bandini Pietà* and consequent attempt to destroy it was due to the fact that, in the furore of artistic creation, Michelangelo had forgotten to sculpt the left leg of the deposed Christ. But the composition is so beautiful and well-balanced that an effort must be made to notice this omission.

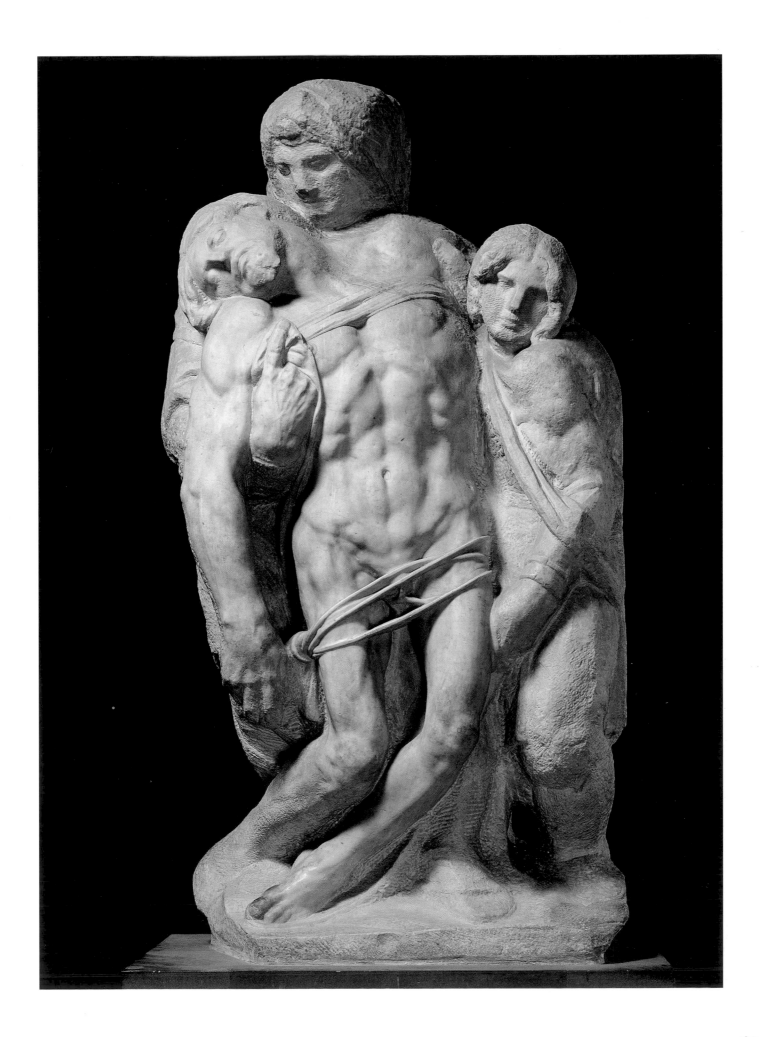

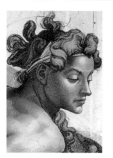

Michelangelo the painter

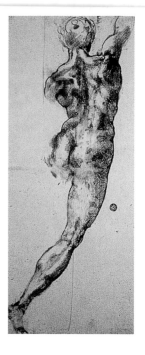

T he first official occasion for Michelangelo to demonstrate his talent as painter was given to him by Soderini, the Gonfaloniere of Florence, who commissioned of him a great fresco to decorate the Council Hall of Palazzo Vecchio. The opposite wall was to be painted by Leonardo da Vinci with the famous episode of the *Battle of Anghiari*, of which there remain only a few studies and later copies such as the so-called *Doria Panel* and the famous drawing by Rubens. But Leonardo's work should be kept in mind for a better understanding of the spirit behind Michelangelo's fresco, also lost to posterity. Nothing remains of it but a set of splendid preparatory drawings and studies of nudes, as well as a copy of the cartoon – which had already become a school for painters – attributed to Aristotele da Sangallo and now in Norfolk (Holkam Hall). While Leonardo chose a battle scene, Michelangelo was inspired by a fact narrated by the fourteenth century historian Giovanni Villani. During the war between Florence and Pisa the Florentine troops, camped near the village of Cascina, had decided to refresh themselves by bathing in the waters of the Arno. Suddenly warned that the enemy was arriving, they rushed to dress and confront their adversaries, overcoming them. Michelangelo decided to portray the moment when the soldiers are hurrying to dress and arm themselves on the banks of the Arno, the moment in which all forces are united before the struggle. In other words, what chiefly interested the artist was the energy of bodies in tension, a motif he already experimented with in the *Battle of the Centaurs*, which must have drawn inspiration from the reliefs on Giovanni Pisano's pulpit in the Pisa Cathedral. For the *Battle of Cascina*, instead, Michelangelo must have had in mind the *Battle of the Nudes* by Pollaiolo. The other important work from this first Florentine period was the *Holy Family with the Infant St. John*, better known as the

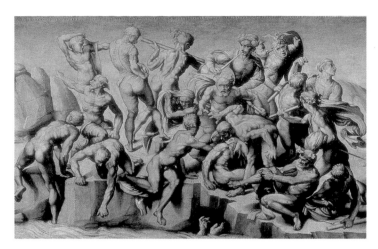

Doni Tondo (see p. 50). In style and technique it is close to the two London paintings, the *Deposition* and the *Madonna and Child, St. John and four Angels*, although the critics date these works at a later time. But the endeavour that was to mark the peak of Michelangelo's

THE FEELING OF THE BODY
On this page, *Deposition in the Tomb* (1510, London, National Gallery). The anatomical knowledge acquired by Michelangelo also thanks to the collaboration of Realdo Colombo, his physician and author of a *De re anatomica* (1559), was skilfully employed by the artist to ensure that the spiritual grandeur of an individual was reflected in his physical presence.

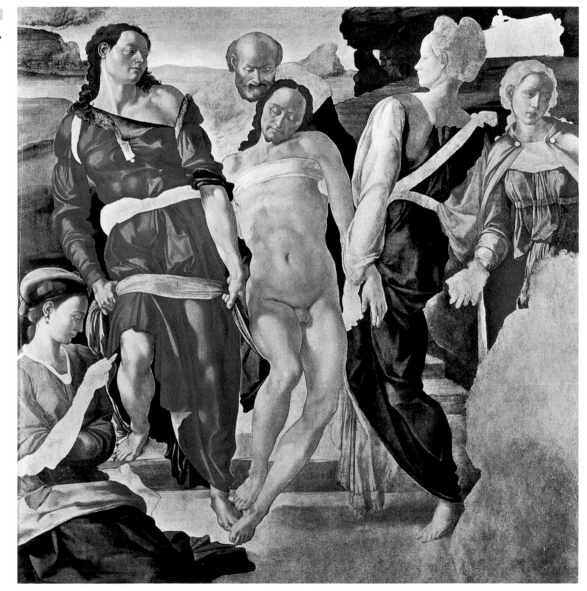

career as a painter, the one that definitively decreed his fame, was the decoration of the vault of the Sistine Chapel. Before Michelangelo, other artists had worked in the great hall of the Sistine Chapel. Perugino, Botticelli, Cosimo Rosselli, Ghirlandaio, Signorelli and others had left magnificent frescoes on the walls depicting stories from the Old and the New Testament. The vault instead was simply decorated with a starry sky painted by Piermatteo d'Amelia. At the suggestion of Bramante, who probably wanted to make trouble for Michelangelo and to distract him from the great project for the Tomb, Julius II asked the artist to entirely renew the decoration of the vault. Michelangelo, anxious to begin the tomb of Julius II as soon as possible, tried to avoid this commitment, suggesting that the work be commissioned to Raphael; but in the end, to please the obstinate pope with whom he had quarreled more than once, he accepted.

The great undertaking lasted from 1508 to 1512, four years of practically uninterrupted back-breaking work to fresco a surface of over a thousand square meters with more than three hundred figures. Michelangelo became so accustomed to looking constantly upward that after having descended from the scaffolding he had to assume the same position in order

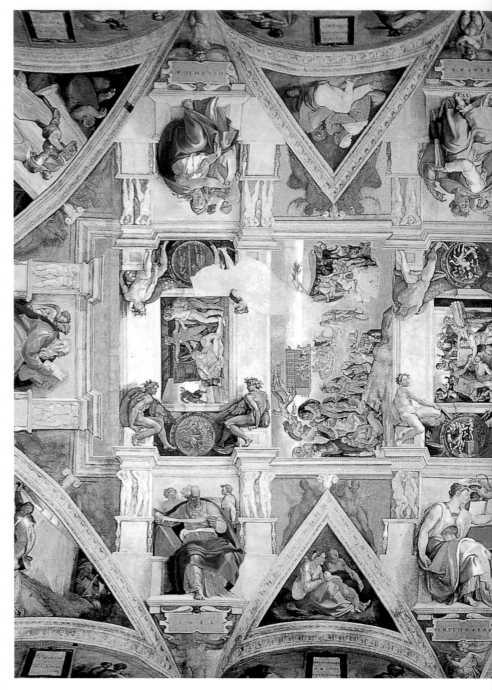

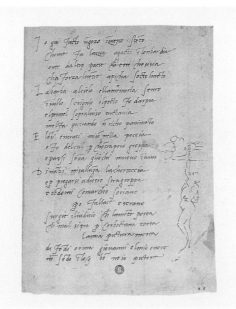

The force of colour
Above, *Vault of the Sistine Chapel* (1508-1512, Vatican City). At left, diagram of the frescoes on the vault. On this page, a letter in which Michelangelo sketches himself painting the vault (1511-1512, Florence, Casa Buonarroti).

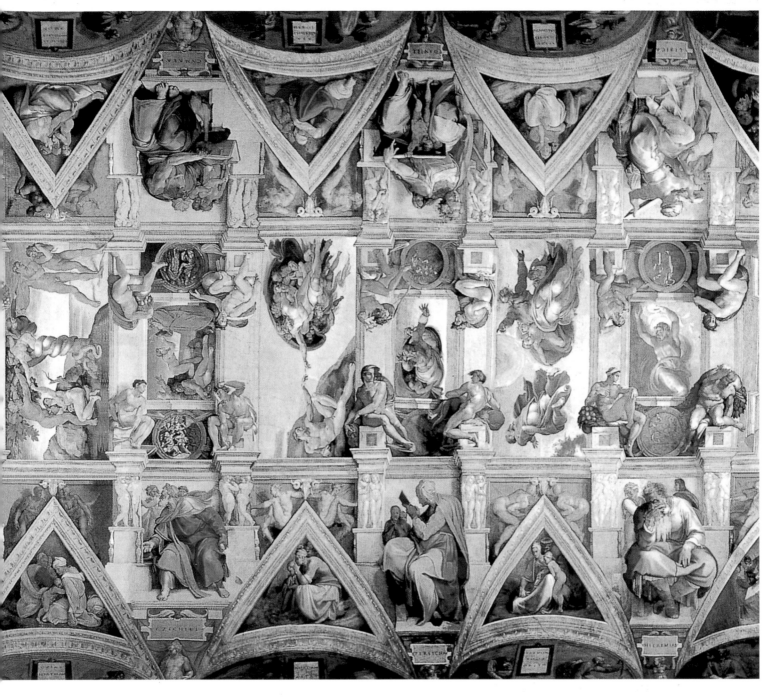

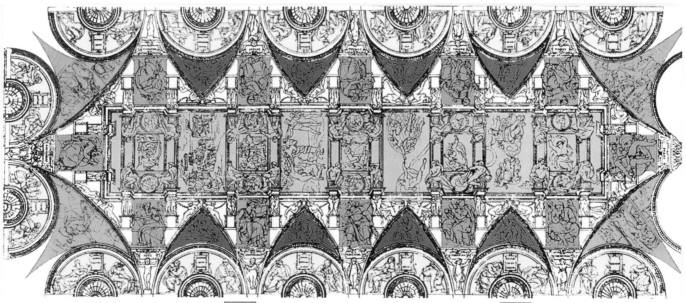

THE FRESCOES ON THE VAULT

Central panels – **Stories from Genesis**

Side panels – **The Seers (Prophets and Sibyls)**

Pendentives – **Miraculous salvation of Israel**

Vaulting cells – **Ancestors of Christ**

Lunettes – **Ancestors of Christ**

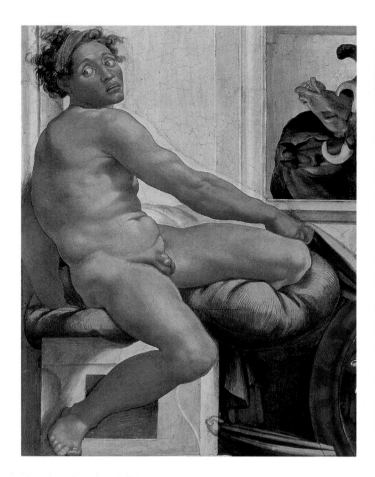

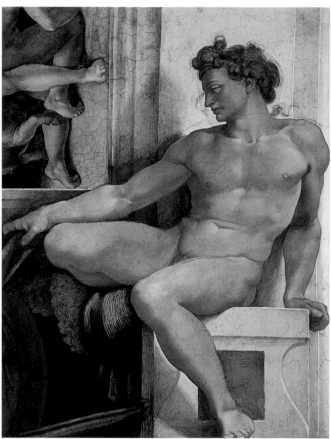

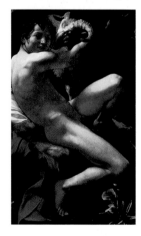

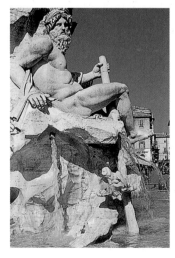

to read a letter. It is unsurprising then that Michelangelo depicted him-self, in a caricature sketched on a letter from that period, in exactly this position. As regards iconography, the frescoes on the vault represent no real innovation. For example, figures of the Prophets and Sibyls who predicted the coming of Christ had already been painted by Pinturic-chio and his assistants in the second room of the Borgia apartments in the same Vatican complex, while the Sibyls alone appear in the marble inlays of the Siena Cathedral where Michelangelo had worked on the tomb of Pius III Piccolomini. The episodes from the Bible as well, from the Creation to the Stories of Noah, are fully consistent with the tradi-tion of the Medieval moralizing Bibles. But it was the way in which the artist organized this material, perfectly familiar to the Christian culture, that not only made the vault a masterpiece but totally renewed the very manner of conceiving the decoration for such a space. Inevitably, it be-came the model for the Roman masterpieces of the next century: from the vault of the Palazzo Farnese Gallery by Annibale Carracci, to that of Palazzo Colonna by Antonio Del Grande and Girolamo Fontana. Michelangelo designed a great rectangular compartment at the center, along the sides of which runs the wall decorated with the Sibyls and Prophets. From the uprights of the backs of the benches depart ten

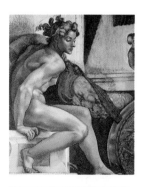

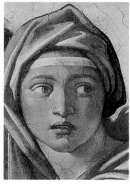

transverse arches that divide the great central compartment into smaller rectangles. Here, like windows opening in the heavens, appear the Biblical scenes narrated in the Book of Genesis. At the bases of the ideal columns that support the arches Michelangelo placed twenty figures of young nudes (known as the *Nudes*) who probably represent humanity before the revelation and perhaps echo the tales told of the savages inhabiting the recently discovered America, who incarnated the aspiration to a pure, uncontaminated world. Some of these figures are holding up a garland of oak leaves and acorns, heraldic symbol of the Della Rovere, the Pope's family, and this suggested to Vasari that they symbolized the golden age inaugurated by Julius II. These figures too became essential models for future generations, from Caravaggio (the *Young St. John the Baptist* of the Capitoline Museums) to Bernini (the *Fountain of the Rivers*). The bronze *Medallions* placed between them bear scenes taken from the Biblical Books of Samuel and Kings. On the vaulting cells and lunettes the artist then painted the figures of Christ's *Ancestors*, while on the lateral pendentives of the vault are Biblical scenes showing the intervention of God in the salvation of Israel. These include the stories of *Judith and Holophernes*, *David and Goliath*, the *Bronze Serpent* and the *Chastisement of Aman*, he who had decreed that the Hebrews should be slaughtered. The pendentives too became a school for artists: Beccafumi, for example, copied the figure of Aman in his *Fall of the Rebellious angels* now in the Siena Pinacoteca. The vault was decorated by Michelangelo in two different stages, and was first uncovered on August 15, 1511, on the occasion of the feast day of Our Lady of the Assumption to whom the chapel was dedicated. Not only did the work arouse general admiration; it also had a precise influence on Raphael, who inserted the figure of Michelangelo, depicted as Heraclius, in his *School of Athens*. Immediately afterward, Raphael employed the motif of the Sibyls in the lunette of the *Virtues* decorating the Stanza della Segnatura and on the front of the arch in the Chigi Chapel in Santa Maria della Pace. Michelangelo frescoed the vault starting from the end, that is from the *Stories of Noah*, in order to free the access as soon as possible. During this monumental work lasting four years, even Michelangelo's style underwent changes, becoming more powerful than ever. This can be clearly seen by comparing the figure of *Zacharias*, seated in composure on the "scranno" (a type of chair reserved to authorities, distinguished by a high back and heavy arms) and the image of *Jonah*, appearing foreshortened. The prophet has now become a giant overflowing from the

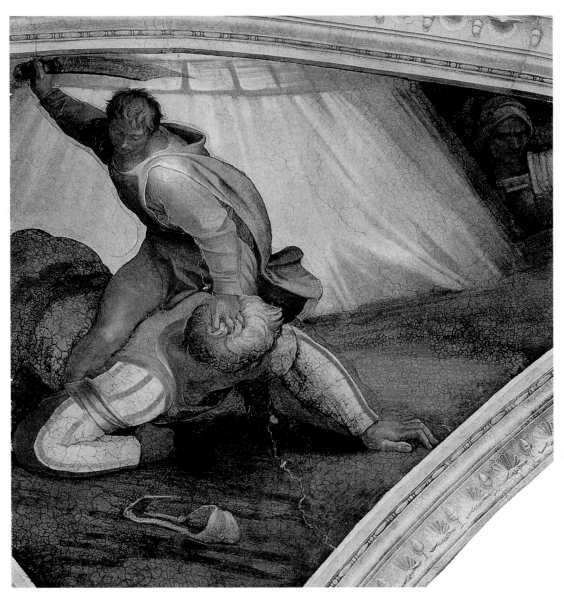

THE OLD TESTAMENT
On this page, *David and Goliath*. Below, *Judith and Holophernes*. «David ran and, standing over the Philistine, pulled out his sword from its sheath and killed him, cutting off his head», (*First Book of Samuel*, XVII, 51). It is this Biblical passage that inspired Michelangelo. While the other scene is based on another passage from the Bible: «Shortly afterward Judith went out and gave the head of Holophernes to her maidservant, who put it in a bag for foodstuffs. Then, as was their custom, both women went together to attend prayers», (*Judith*, XIII, 9-10).

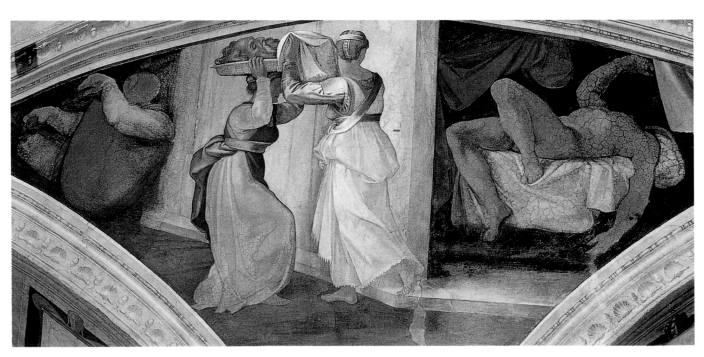

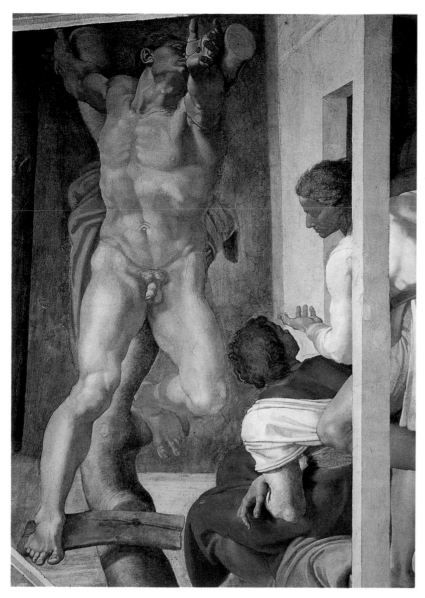

IN THE SAME POSITION
Above, at left,
*The Chastisement
of Aman*
(detail).
At right,
Domenico Beccafumi,
*Fall of the
Rebellious angels*
(detail,
c. 1524,
Siena, Pinacoteca
Nazionale).
Note that
the figure portrayed
by Beccafumi is
in the same position
as Aman.

chair. Michelangelo returned to work on the Sistine Chapel twenty-five years after having completed the vault, to create one of the most tormented works in the history of painting: the *Last Judgement* (see p. 56).

This was not, however, the last work of Michelangelo the painter. For Pope Paul III Farnese he painted, again in the Vatican, the frescoes in the Pauline Chapel. Erected by Antonio da Sangallo in 1540, the chapel was a private one and the frescoes, depicting the *Conversion of St. Paul* and the *Crucifixion of St. Peter*, were designed as macroscopic icons on which to meditate. The first episode, taken from the *Acts of the Apostles* (IX, 3 ff.) and painted between 1542 and 1545, was a stimulus to reflect on the value of Grace; the second, taken from the *Legenda Aurea* of Jacopo da Varagine and painted between 1545 and 1550, evoked in the beholder an understanding of personal sacrifice in the name of Christ.

THE PROPHETS

On this page, *Zacharias* and, on the facing page, *Jonah*. The figures of these two prophets eloquently express the two extremes of Michelangelo's stylistic development in the frescoes on the vault. Zacharias, painted first, is rigorously inscribed in the space delimited by the chair he sits on. Jonah, instead, bursts forth enormous as a titan.

THE LAST WORKS

Below, one of Michelangelo's last paintings, the *Conversion of St. Paul* (1542-1545, Vatican City, Palazzi Vaticani, Pauline Chapel). The last painting of monumental dimensions accomplished by the artist shows a further development of Michelangelo's interest in representing masses of humanity distributed over the wall according to precise criteria of composition. Beyond its appearance at first sight, in fact, the *Conversion of St. Paul* is traversed by a coil that links the image of Christ in Heaven with that of the saint lying on the ground. Note that Paul's body lies just at the lower margin of this compositional line. In other words, Michelangelo has developed new pictorial solutions in harmony with those already devised for the *Last Judgement*.

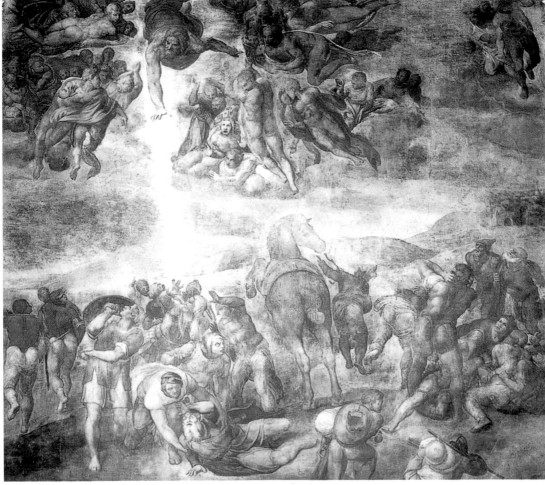

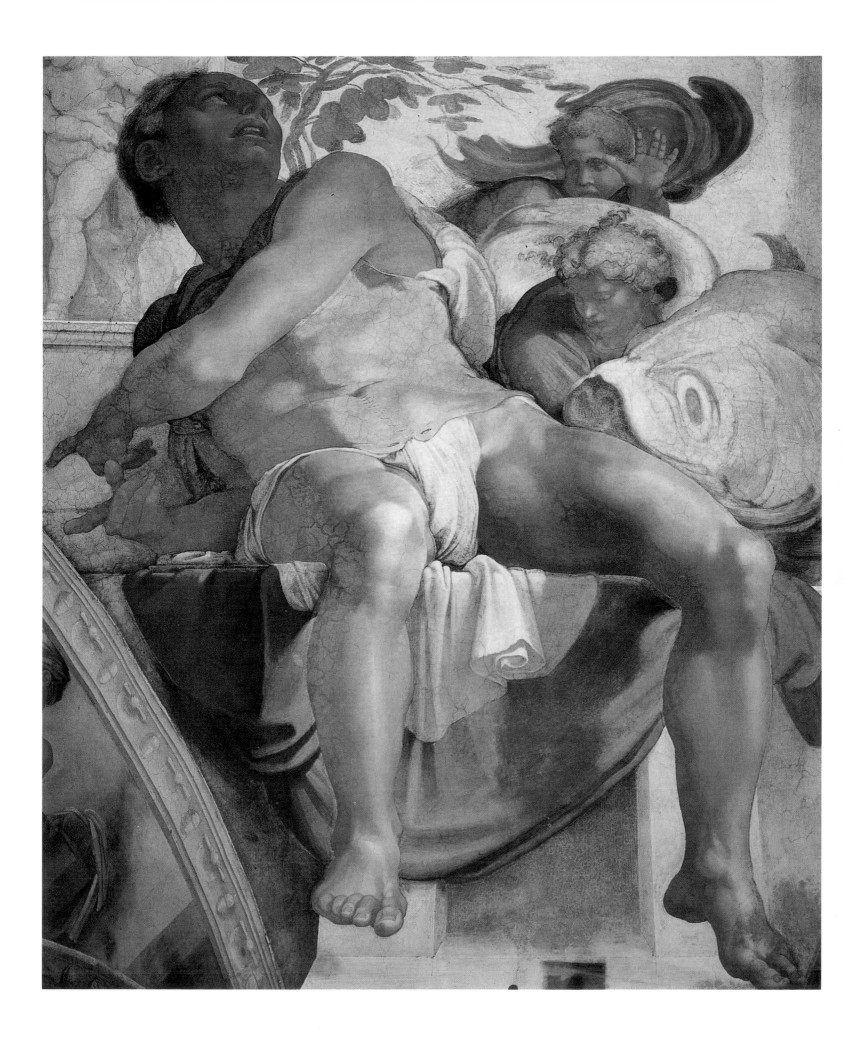

Michelangelo the architect

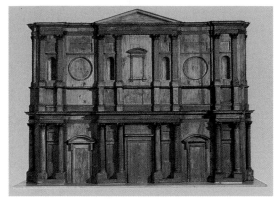

P ope Leo X was the first to recognize Michelangelo Buonarroti's genius as architect. It was he in fact who chose Michelangelo's project from among the many presented for the facade of San Lorenzo, considered by the Medici almost as their family church. The striking element of Michelangelo's project was of course the imposing sculptural program that the artist had conceived for the work, but also the originality of his reinterpretation of the vocabulary of classical architectural, put at the service of a Christian building. The latter aspect can still be appreciated today in observing the beautiful wooden model in the Casa Buonarroti (1518), since the facade of the church has never been built.

Michelangelo worked for years on the building complex of San Lorenzo. The Pope gave him another commission in 1520, for the New Sacristy. Then Giulio de' Medici, having become pope under the name of Clement VII at the death of his cousin Leo X, entrusted to him the construction of the Laurentian Library in 1523. Although reproducing exactly the lay-out and height of the Old Sacristy, built by Brunelleschi between 1421 and 1426, the New Sacristy is universally considered to be the prototype of what was to be termed by the critics "Mannerist architecture", an architecture capable of disregarding the golden rule of Renaissance balance to create a new, more vibrant and organic order.

From the symbolic point of view as well, the structure of the building is indissolubly linked to the sublime sculptural decoration that integrates and completes it. If the dome represents the empyrean (and not by chance emulates the coffered decoration of the Pantheon in Rome), the walls interrupted by aedicules with the statues of Giuliano II of Nemours and Lorenzo II of Urbino, surmounting the allegorical figures of *Day* and *Night*, *Dawn* and *Dusk*, symbolize the human world

MEDICI'S ARCHITECT
Above, *Wooden model for the facade of San Lorenzo Basilica* (c. 1519, Florence, Casa Buonarroti). For the monumental complex of San Lorenzo, consisting of the New Sacristy and the Library, Michelangelo realised only the facade of the church, whose Basilica-like interior had been completely renovated in 1421 by Brunelleschi. Michelangelo's wooden model is all that remains of a project never carried out. Difficulties arose in bringing the slabs of marble from Pietrasanta, the quarry chosen by Leo X (in place of Carrara, preferred by Michelangelo), which irritated the artist to the point of cancelling the contract.

**ARCHITECTURE
AND SCULPTURE**
Below, left,
floor-plan
of the *Little
secret library*
for the
Laurentian Library
(before 1525,
Florence,
Casa Buonarroti).
Below,
*Hall of the
"Ricetto"*
of the Laurentian
Library
(1559).
Below, right,
detail of the *Interior
of the New Sacristy*
in San Lorenzo
Basilica,
Florence.

marked by the passage of Time. This interweaving of meanings is emphasized by Michelangelo through formal stratagems. The walls of the chapel, in fact, are no longer simple elements of separation from the outside serving to delimit a space of their own. They are instead plastic organisms which concur in defining the inner room, rendering it vital and pulsating. A door or a window is not a simple opening in a wall, but a modification of the structure of the wall, which opens up to receive the one or the other of these elements. For this reason the stairway in the "Ricetto" of the Laurentian Library seems almost an organic extension of the corridor in the reading room, widening out to flow downward, separating into steps of rounded, harmonious shapes. It is not surprising that Michelangelo sculpted in clay the models for his architecture, nor is it difficult to grasp the great sense of plasticity in the projects designed by the artist for the defense of Florence in 1529, when he was appointed «expert in fortresses».

That was the city's desperate attempt to oppose the overwhelming power of the troops of Charles V and to revive the ephemeral dream of the Republic, born two hundred years earlier, after the expulsion of the Medici family from the city. This was a crucial moment in the life of the artist, since having undertaken to defend the Republic of Florence meant opposing the members of that family which had

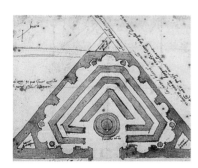

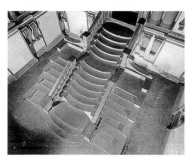

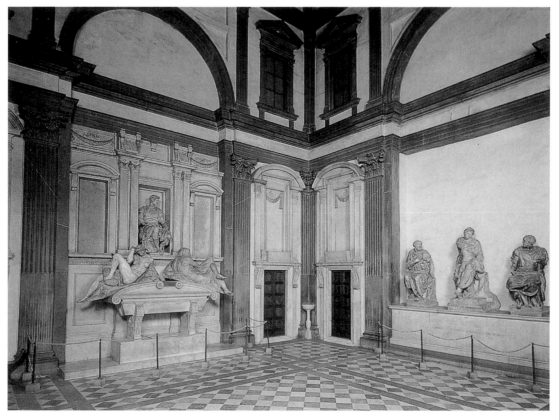

made him great. It is thus unsurprising that Michelangelo, at the fall of the Republican regime (August 12, 1530), went into hiding until he had received the pardon of Clement VII, and could resume work on the San Lorenzo building complex. These are the only works of architecture accomplished by Michelangelo during his second Florentine period, and later definitively completed by Giorgio Vasari and by Bartolomeo Ammannati.

The artist was not engaged in problems of architecture again until 1546 when, contemporary with the decoration of the Pauline Chapel, Paul III asked him to complete the family palace left unfinished at the death of Antonio da Sangallo. Palazzo Farnese, later completed by Giacomo della Porta, was to become a model for the patrician architecture of the latter half of the 16th century, as shown by the fact that Domenico Fontana used the same forms for the Lateran Palace in 1586.

Michelangelo's great urban planning endeavor in Rome was however the Piazza del Campidoglio, begun in 1538. For this project the artist applied to the scenography those perspective stratagems that were to become highly fashionable a hundred years later. To eliminate the disproportion between the length and width of the square, Michelangelo oriented the two palaces at the sides so that they were not exactly perpendicular to the Palazzo Senatorio in the background. They are in fact divergent from the stairway that leads up to the

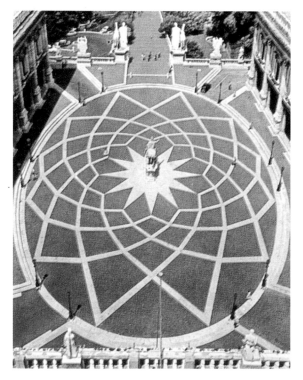

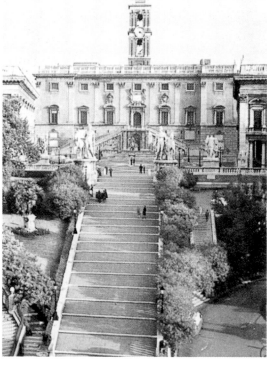

MICHELANGELO AT ROME
Below, two views of the *Piazza del Campidoglio* (1538-1564). On the opposite: at left, the dome of St. Peter's; at right, a view of the *St. Peter's Basilica;* the facade is the work of Carlo Maderno (1612). Michelangelo did not live to see the square completed. The only building which was constructed partially under his guidance was the Palazzo dei Conservatori (at right, with the shoulders of the stairway), subsequently completed by Giacomo della Porta and Girolamo Rainaldi, who also built the Palazzo Nuovo, architecturally identical to the former but constructed staring in 1644. Michelangelo was directly concerned in the base and the collocation of the statue of *Marcus Aurelius* (then considered to be a portrait of Constantine), as well as the realisation of the stairway of the Palazzo Senatorio, competed under the direction of Giacomo Della Porta and Girolamo Rainaldi.

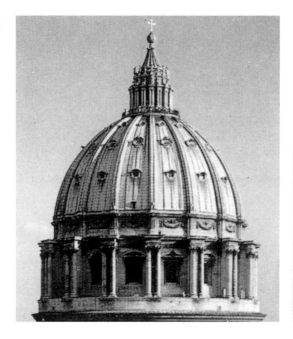
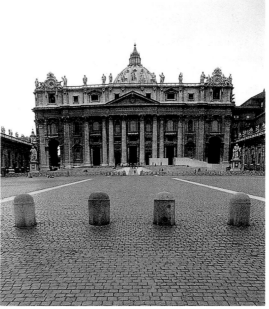

THE DOME OF ALL CHRISTIANS
When Sixtus V became pope, in 1585, the Dome of St. Peter's had been constructed only up to the height of the lantern and Michelangelo had now been dead for over twenty years. The building was continued first by Pirro Ligorio. Dismissed perhaps because he deviated from Michelangelo's project, he was replaced by Giacomo Barozzi known as Vignola. Subsequently Gregory XIII appointed Giacomo Della Porta, and Sixtus V later named Domenico Fontana as his collaborator. The dome was completed in slightly less than two years, from 1588 to 1589, and another seven months were sufficient to top it with the lantern. It is a "double shell" construction divided into sixteen sections in which three orders of windows open out. The dome for all Christians had finally been born.

square. Both the right and the left sides of the square, although actually shorter than the side at the back, give the impression to those mounting the stairway of being exactly the same. The impression is that of entering an area which is no longer rectangular, but square. The effect is heightened by the design of the paving which, based on the motif of intersecting circles, optically confirms the regularity of a space that appears such only thanks to a trick in perspective. Michelangelo, however, was able to see the realization of only a few elements of the entire project (later to be altered by Della Porta and by Rainaldi): the base of the equestrian statue of *Marcus Aurelius* and the stairway with its two lateral ramps, re-utilized by the artist with some variations in Bramante's courtyard of the Pigna in Vatican (c. 1550). But the commitment that occupied him to the end, and that became a kind of torment, was the construction of the new St. Peter's and its majestic dome. Appointed architect of the Fabric of St. Peter's in 1546, as replacement for Antonio da Sangallo, Michelangelo, while referring to Bramante's grandiose project, simplified and re-dimensioned it, designing a building with central plan that had in the dome its plastic, symbolic apex. The St. Peter's of Michelangelo was entirely distorted by the 17th century intervention of Maderno, and the dome is the most significant survival of the initial project. The artist managed to supervise the construction as far as the entire base is concerned. To this latter period belong the construction of Porta Pia (see p. 58) and the restructuring of Santa Maria degli Angeli.

Michelangelo's colours

T he proverbial rivers of ink have flowed over the issue of what is unquestionably the restoration of the century, that of the vault of the Sistine Chapel and the *Last Judgement* by Michelangelo. Lasting thirteen years without a pause, from 1981 to 1994, the work has led to the sensational realization that everything the critics have written about Michelangelo's colours must be rapidly corrected.

The idea that the artist ignored «everything that concerns colour», affirmed by the French Academic Roger de Piles in the late 17th century, was perpetuated in the following century. The erudite Michel de Lalande, in his voluminous *Voyage en Italie* written in 1769 and very famous at the time, stated in regard to the vault of the Sistine Chapel: «The color tends toward brick and gray; but these errors are compensated for by the drawing».

The 19th century made no exception but, contrary to previous opinions, began to consider the presumed lack of sensitivity to colour a merit, if a man as highly cultivated and aesthetically refined as Gio-

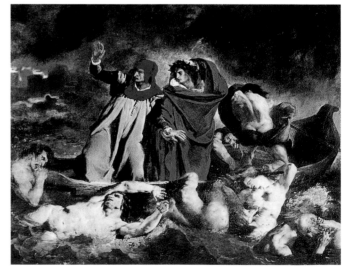

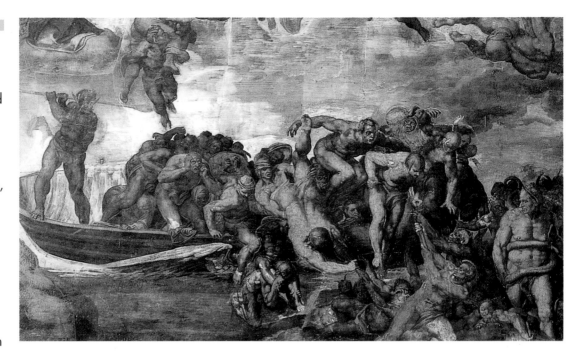

THE INFERNAL BOAT
On this page,
the *Last Judgement*
(detail with the so-called
Charon's boat,
prior to restoration;
1536-1541, Vatican
City, Sistine Chapel).
«But those souls there,
naked, in despair,/
changed colour and
their teeth/began to
chatter at the sound
of his announcement
of their doom [...].
The devil Charon,
with eyes of glowing
coals,/summons them
all together with
a signal,/and with
an oar he strikes
the laggard sinner»
(*Inferno*, III, 100-111).
These are the verses
of Dante which
inspired Michelangelo
(who knew the *Divine
Comedy* by heart)
for the forceful scene
represented at
the lower right
on the wall of the
Last Judgement.
The presence
of the altar and
the consequent use
of candles for
liturgical purposes
blackened the fresco,
conferring on
Michelangelo's
colours the haunting
effect that so
powerfully struck
the painters
of the Romantic
period.
Paradoxically, the
"dirty" Michelangelo
was to become one
of the roots of
Romantic and
Symbolist painting.

van Battista Niccolini, tragic poet and friend of Foscolo, could declare: «That work would only be harmed by colour. It would no longer be a mental vision of a fact that is above human concepts».

In other words, the new romantic conception of art discovered a great aesthetic model in the chill colours of the "dirty" Michelangelo, prior to this impressive restoration. It was, in fact, a question of dirt. The frescoes had been blackened by the smoke of candles and by extensive touching-up with animal-based glue to keep the paint from peeling off. The tendency «toward brick and grey», as had been stated by De Lalande, seemed to confer greater power on the artist's figures. They became titans made of painted rock, haunting the minds of the painters of the day. And it is easy enough to discern the matrix of the concept of Michelangelo's "terribilità" in works such as the *Prometheus* of Heinrich Füssli, who spent eight years in Italy (from 1770 to 1778), most of this time dedicated in studying the Michelangelo of the Sistine Chapel.

Contemporaneously there occurred another cultural phenomenon, a highly important one: the rediscovery of Dante. The apocalyptic visions of Dante's hell were thus interpreted in the light of the "dirty" Michelangelo not only by Füssli, but also by William Blake and Delacroix, who painted *Dante's boat*, with dark tones like those of the Sistine Chapel, in 1822. But if the "dirty" Michelangelo is sufficient to explain the romantic leanings of some of the greatest European painters in the late 18th and early 19th centuries, it is in sharp contrast with the bold colour combinations of Mannerism. Only restoration, in

fact, by restoring the original color scheme, has allowed us to understand the model influencing the painters who were Michelangelo's contemporaries, and why Giampietro Lomazzo had written that in the artist's work «nothing better could be done, in drawing and in coloring». Only the "clean" Michelangelo can explain the daring colour schemes used by Raphael in his *Transfiguration*, with its combination of pinks and yellows. Only the "clean" Michelangelo can explain the rainbow of colours in Pontormo's *Deposition* in Santa Felicita, or that of Rosso Fiorentino in the Volterra *Deposition*, or again the iridescent shimmer of Domenico Beccafumi's *Fall of the Rebellious angels* in the Siena Pinacoteca. Undoubtedly, each of these artists developed a poetics of his own, but the audacity of Bronzino's colour combinations in the enameled hues of a work such as *Time which uncovers Lust* could come only from the lesson taught by the vault of the Sistine Chapel. Here Michelangelo had in fact provided an ideal central light that transformed the entire decoration into a kaleidoscopic rainbow.

In the final analysis, all of this only emphasizes once again the greatness of the artist whose work, whether "dirty" or "clean", became an unparalleled model for all the others.



THE COLOURS OF THE RENAISSANCE
On this page, from the left, Pontormo, *Deposition* (1525-1528, Florence, Santa Felicita, Capponi Chapel); Rosso Fiorentino, *Deposition* (1521, Volterra, Pinacoteca Civica). On the opposite page, above, from the left: Raphael, *Transfiguration* (1518-1520, Vatican City, Pinacoteca Vaticana); Agnolo Bronzino, *Time which uncovers Lust* (1540-1550, London, National Gallery). Below, from left: *Last Judgement*, detail of the right lunette before and after restoration (1536-1541, Vatican City, Sistine Chapel). Recent restoration has restored to the Sistine Chapel the original brilliance of its colours which harmonise well with the 15th century colourfulness of the artists – Perugino, Botticelli, Pinturicchio, and Cosimo Rosselli – who preceded Michelangelo in decorating the Sistine Chapel.



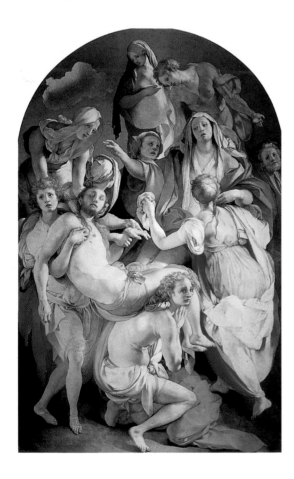

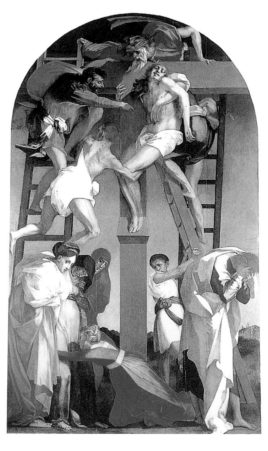

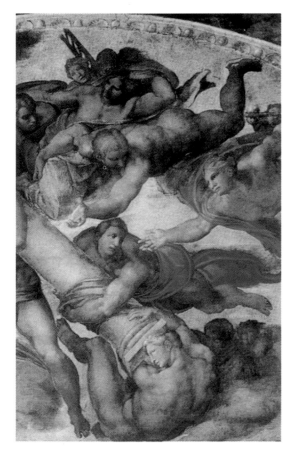

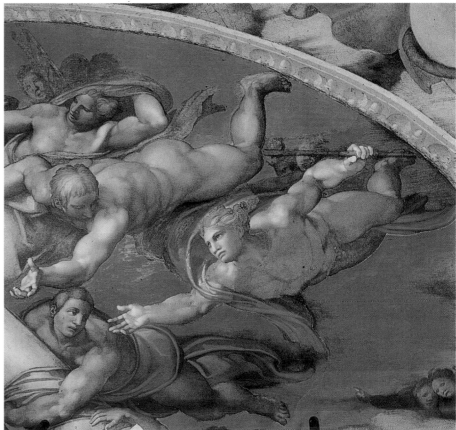

Chronology	1475	1480	1490	1500	1505
Michelangelo	**1475** On March 6 Michelangelo Buonarroti is born in Caprese, near Arezzo, the second child of the Magistrate Lodovico di Leonardo and his wife Francesca.	**1481** Michelangelo's mother Francesca dies. **1487** He enters the workshop of Domenico Ghirlandaio in Florence. **1489** Studies the sculptures in the Medici collection at the Monastery of San Marco; is welcomed to the court of Lorenzo the Magnificent.	**1492** Michelangelo sculpts a wooden *Crucifix*, the *Battle of the Centaurs* and the *Madonna of the Stairs*. **1494** Goes to Venice, then to Bologna. **1496** Begins the *Bacchus* in Rome. **1499** Finishes the *Pietà* for St. Peter's in Vatican.	**1501** Michelangelo returns to Florence **1503** Around this date executes the *Taddeo Tondo* and *Pitti Tondo*. **1504** Finishes the *David*; executes the Bruges *Madonna with Child*, the *St. Matthew* and the cartoon for the *Battle of Cascina*.	**1505** Michelangelo goes to Rome to build the funerary monument of Pope Julius II, but subsequent to disagreements returns to Florence the following year. **1507** Paints the *Doni Tondo*. **1508** Begins to fresco the vault of the Sistine Chapel.
Italy	**1475** War between Venice and the Turks. **1478** In Florence Giuliano de' Medici is killed but the Pazzi conspiracy against Medici rule fails.	**1482** Around this date Botticelli paints the *Birth of Venus* and the *Primavera*. **1483** Birth of Raphael. **1488** In Venice Giovanni Bellini paints the *Frari Triptych*.	**1492** Lorenzo the Magnificent dies in Florence. Alexander VI Borgia is elected Pope. **1494** Piero de'Medici is exiled: Charles VIII of France enters Florence. **1495** Leonardo works on the *Last Supper* in Milan.	**1500** Leonardo stays in Venice. **1503** Death of Alexander VI; Julius II elected Pope. **1504** Giorgione paints the *Castelfranco Altarpiece*, Raphael signs the *Marriage of the Virgin*.	**1505** Julius II conquers Bologna and annexes it to the Papal State; *St. Zachary Altarpiece* by Giovanni Bellini **1508** League of Cambrai against Venice. **1509** Raphael begins the Vatican *Stanze*.
Netherlands	**1477** Maria, daughter of Charles the Bold, marries Maximilian of Austria, bringing him as dowry the Duchy of Burgundy and thus Brabant.	**1482** Treaty of Arras for the division of the Burgundy heritage: Flanders remains with the Hapsburgs. **1483** The *Adoration of the Shepherds* by Hugo van der Goes arrives in Florence.	**1490** Around this date the painter Geerten tot Sint Jans dies at Haarlem. **1494** The Flemish painter Hans Memling dies.	**1503-1504** Bosch paints the *Triptych of Delights*.	**1506** The *Madonna* sculpted by Michelangelo for the Church of Notre-Dame arrives at Bruges.
France	**1477** At the death of Charles the Bold Louis XI takes possession of Burgundy.	**1480** Around this date the painter Jean Fouquet dies. **1483** Louis XI dies, succeeded by his son Charles VIII.	**1490** The painter Nicolas Froment, who painted the *Burning Bush* in Aix Cathedral, dies. **1494** Charles VIII invades Italy, claiming the Kingdom of Naples. **1498** Charles VIII dies.	**1501** The French under Louis XII occupy Naples. The Master of Moulins paints for the Duke of Beaujeu the triptych with the *Virgin in Glory*. **1504** With the treaty of Lyon the war between France and Spain ends.	
Germany		**1481** Michael Pacher executes the alter of the Church of St. Wolfgang in Salzburg. **1483** Birth of Martin Luther, father of the Protestant Reformation.	**1493** Maximilian of Hapsburg becomes Emperor. **1496** Marriage of Philip the Fair of Hapsburg and the Infanta of Spain Joan the Mad. **1498** Dürer engraves a series of woodcuts inspired by the *Apocalypse* of St. John.	**1503** In Vienna Lukas Cranach paints the *Crucifixion*.	**1505** Dürer arrives in Venice for his second stay. **1508** The Emperor joins the League of Cambrai against Venice.

1510	1520	1530	1540	1550	1560
1513 Michelangelo sculpts the *Moses* and two *Slaves* for the tomb of Julius II. **1515** Moves back to Florence. **1516** Is commissioned to design the facade of San Lorenzo. **1519** Begins the *Slaves*.	**1520** Michelangelo works on the New Sacristy of San Lorenzo. **1524** Work on the Laurentian Library begins. **1529** Michelangelo participates in the defence of Florence during the siege of Charles V.	**1530** Michelangelo sculpts the *Apollo* and resumes work on the New Sacristy. **1534** Completes the *Victory Genius* and definitively leaves Florence for Rome. **1536** Begins to fresco the *Last Judgement*.	**1540** Michelangelo finishes the bust of *Brutus*. **1541** Completes the *Last Judgement*. **1542-1545** Finishes the tomb of Julius II in San Pietro in Vincoli. **1546** Becomes architect of the Fabric of St. Peter's.	**1550** Michelangelo finishes the frescoes in the Pauline Chapel. **1552** Completes the Campidoglio stairway. **1553** Works on the *Bandini Pietà*.	**1564** On February 18 Michelangelo dies at his home in Rome, leaving the *Rondanini Pietà* unfinished.
1510 Giorgione dies. **1513** Julius II dies, and Leo X Medici is elected pope. **1516** Giovanni Bellini dies. **1519** Leonardo da Vinci dies.	**1520** Raphael dies. **1526** Carpaccio dies. **1527** Sack of Rome, expulsion of the Medici from Florence, Sansovino and Aretino seek refuge in Venice.	**1530** Charles V is crowned Emperor by Pope Clement VII at Bologna. The imperial army reconquers Florence. **1534** Paul III Farnese is elected pope. **1537** In Florence Alessandro de' Medici is assassinated; Cosimo I becomes duke.	**1541** Giorgio Vasari arrives in Venice. **1542** The Holy Office is instituted. **1545** The Council of Trent is convened. **1547** Tintoretto paints the *Last Supper*. **1549** Paul III dies.	**1550** First edition of Vasari's *Lives*. Julius III is elected Pope. **1555** Veronese begins decorating the Church of San Sebastiano. **1556** Pietro Aretino dies.	**1563** The Council of Trent concludes. **1564** The Congregation of the Council decides to have the portions of the *Last Judgement* deemed obscene painted over. **1568** Second edition of Vasari's *Lives*.
1511 Erasmus of Rotterdam publishes his *In Praise of Madness*. **1516** The Flemish painter Hieronymus Bosch dies.	**1526** Luca da Leida paints the triptych of the *Last Judgement*. **1527** The painter Pieter van Aelst returns to Bruxelles after a long stay in Italy.	**1530** The Flemish painter Quentin Metsys dies.	**1540** In Antwerp the artists' guild organises the first market for art objects and contemporary paintings.	**1552-1554** Pieter Bruegel the Elder makes a journey to France and Italy.	**1566** The wars for freeing the Netherlands from Spanish domination begin. **1566-1567** A wave of Calvinist iconoclasm sweeps over Spanish Flanders.
1513 Louis XII tries to reconquer Milan, is defeated at Novara. Dies the following year. **1515** François I, the new King, reconquers Milan. **1516** The Peace of Noyon sanctions French domination over the Duchy of Milan.	**1523** Jean Clouet is appointed court painter. **1525** François I is defeated by the Imperial troops at Pavia and taken as prisoner to Madrid. **1528** Work begins on the Castle of Fontainebleau.	**1535** Rosso Fiorentino begins decorating the Gallery of the Castle of Fontainebleau. **1536** Third war between François I and the Emperor Charles V.	**1540-1545** Benvenuto Cellini works at the service of François I. **1542** Fourth war with Spain. **1541** François Clouet is appointed court painter. **1547** Henri II becomes King.	**1550** The spread of Calvinism in France begins. **1552** Henri II, at war with Charles V, allies himself with the Protestant Princes. **1559** Peace of Cateau-Cambrésis with Spain, François II becomes King.	**1562** Catherine de' Medici, regent of Charles IX, grants partial freedom of religion to the Huguenots. **1563** Primaticcio and the sculptor Germain Pilon begin the tomb of Henri II and Catherine de' Medici in Saint-Denis.
1514 Dürer engraves *Melancholy I*. **1517** Martin Luther affixes his 95 theses to the door of the Wittemberg Cathedral. **1519** Maximilian's successor, Charles V, re-unites the Empire and the Kingdom of Spain.	**1521** The Diet of Worms bans Lutheranism. **1524** The Peasants' War. **1528** In Ratisbone Altdorfer paints the *Battle of Alexander and Darius at Isso*.	**1530** Charles V is crowned Emperor. **1531** The Protestant princes form an alliance against Charles V and the Catholic princes. **1533** The sculptor and engraver Veit Stoss dies. **1538** The painter Albrecht Altdorfer dies.	**1545** The painter and engraver Hans Baldung Grien dies. **1546** Death of Luther. **1547** Charles V defeats the league of Protestant princes in the battle of Mühlberg. **1548** The Diet of Augsburg is inaugurated.	**1555** With the peace of Augsburg the war against the Lutherans comes to an end. **1556** Charles V abdicates: Spain passes to his son Philip II, the imperial throne to his brother Ferdinand I. **1558** Charles V dies.	**1564** At the death of Ferdinand I, his son Maximilian II becomes Emperor and grants freedom of religion to the Protestants.

THE DAVID

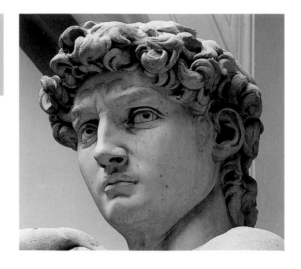

The sculpting of the *David* was a real challenge to Michelangelo, and was simultaneously the literal application of that concept the artist was to express years later in a sentence which is exceptionally clear and striking, and which has become famous. «I consider sculpture to be that which is done by removing», he was to write to the renowned Florentine philologist and historian Benedetto Varchi, thus leaping into a debate on the supremacy of painting or sculpture which has yet to be concluded. Now if there exists a work accomplished «by removing», by eliminating the superfluous from the block of marble to let it emerge, it is undoubtedly the *David*. The young artist was entrusted with a block of marble that had first been cut for Agostino di Duccio so that, between 1463 and 1464, he could sculpt a Prophet or, more probably, a David to be placed on one of the Cathedral buttresses. The dimensions of the block were, however, unsuitable: too narrow and too tall. After Agostino, Antonio Rossellino had also tried, but without results, so that the block of marble remained there, abandoned in the courtyard of the Opera del Duomo until August 16, 1501, when Michelangelo began to work on it, completing his statue three and a half years later.

A symbol of the liberty of Florence, Michelangelo's *David* falls within the iconographic tradition in which the works of Donatello and Verrocchio had flourished. But as compared to these models, Michelangelo, in deciding to portray David entirely nude (without even a cap or a sword, as in Donatello's *David* of 1440), purposely triggered visual references to the image of Hercules, another symbol of Florence. It may be that Michelangelo was inspired by the small relief sculptured perhaps by Giovanni d'Ambrogio for the Porta della Mandorla in Santa Maria del Fiore, showing the demi-god entirely nude and standing in a position similar to that of Michelangelo's masterpiece. Moreover, it is probable that Michelangelo was acquainted with the *Hercules* of Bertoldo di Giovanni (Michelangelo's tutor in the Medicean Academy), now at the Victoria and Albert Museum in London.

David
marble
height 517 cm; c. 1501-1504.
Florence, Accademia Gallery

THE SYMBOL OF LIBERTY
«...a young David with the slingshot in his hand, so that, just as he had defended his people and governed them with justice, he who governs that city must heartily defend it and justly govern it».
With these words Vasari explains the symbolic and political meaning of Michelangelo's *David*, which represents the aspiration toward freedom, justice and good government.

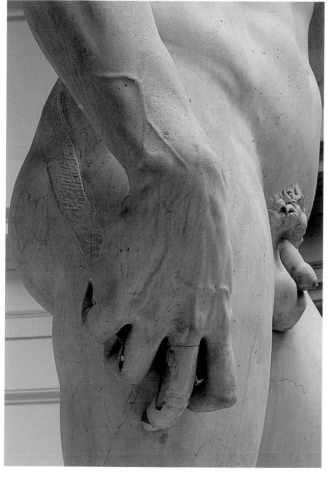

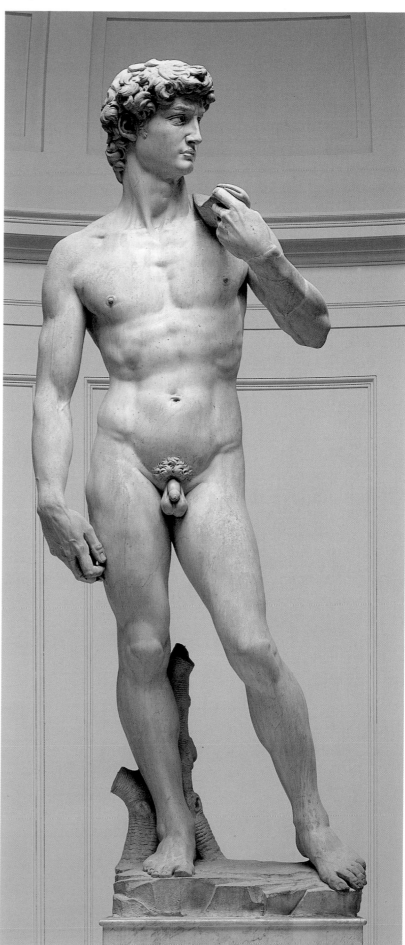

THE DONI TONDO

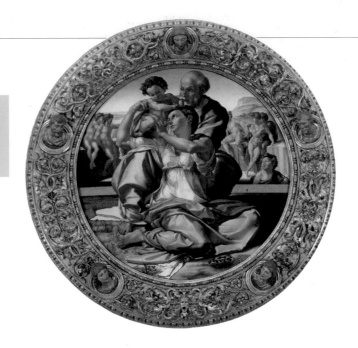

To clearly realise the force of the pictorial invention in the *Doni Tondo* and the innovation it represented within the contemporary panorama of painting, it is sufficient to compare Michelangelo's *Holy Family* (this is the real name of the work) with paintings of the same subject such as that of Luca Signorelli now in the Uffizi Gallery, completed some twelve years before Michelangelo's masterpiece. In Signorelli's work in fact, the circular form of the support is reflected only in the position of St. Joseph and in the inclination of Maria's back, but for all the other elements the scene could have been painted on a rectangular panel without any great change. In Michelangelo's *Doni Tondo* instead, the entire composition is organised in relation to the circular form. The position of the Virgin's legs, which follow the lower edge of the support, her arms and the placing of the wall in the background tend, taken as a whole, to transform the circle into a sphere that assumes the transparency of crystal.

Moreover, the twisting postures of the central group, probably inspired by the "node" of figures which make up the *Laocoon* and suggesting in its turn the position of the fainting Virgin in Raphael's *Baglioni Altarpiece*, manage to occupy the three dimensions of space simultaneously.

Painted for the wedding of Agnolo Doni and Maddalena Strozzi, Michelangelo's *Holy Family* alludes to the client's name through the gesture of the elderly Joseph who offers and thus "donates" the Infant Jesus to Maria. The symbolic reading proposed by the critics does not stop here, however, and sees in the nude figures in the background, the forerunners of those that people the Sistine Chapel, an allegory of humanity "ante legem", that is before the revelation. Mary and Joseph instead are considered to represent humanity "sub lege", illuminated by the revealed law of Moses. Mediating between the one and the other is the infant John the Baptist, whose features are too similar to those of Jesus not to mark him as the forerunner. The Child, in fact, represents humanity "sub Gratia", after the coming of Christ.

Doni Tondo (Holy Family with the Infant St. John)
tempera on wood
diam. 120 cm (with frame 170 cm);
c. 1506-1508.
Florence, Uffizi Gallery

A "NODE" OF FAITH
The composition of Michelangelo's *Holy Family* appears thus, as an eternal Gordian knot weaving together faith, art and prayer. Completed by the splendid wooden frame purposely carved for it by Lorenzo Ghiberti, the *Doni Tondo* as it is commonly called, is the result of a fortunate encounter between Michelangelo's genius and the keen perception of a great collector such as Agnolo Doni, who commissioned, in those same years, his own portrait and that of his wife Maddalena Strozzi of the young Raphael who was staying in Florence at the time.

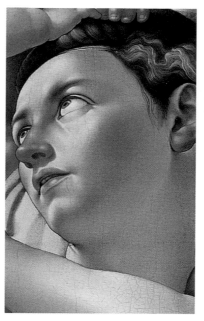

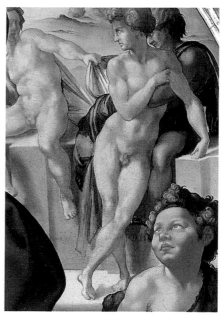

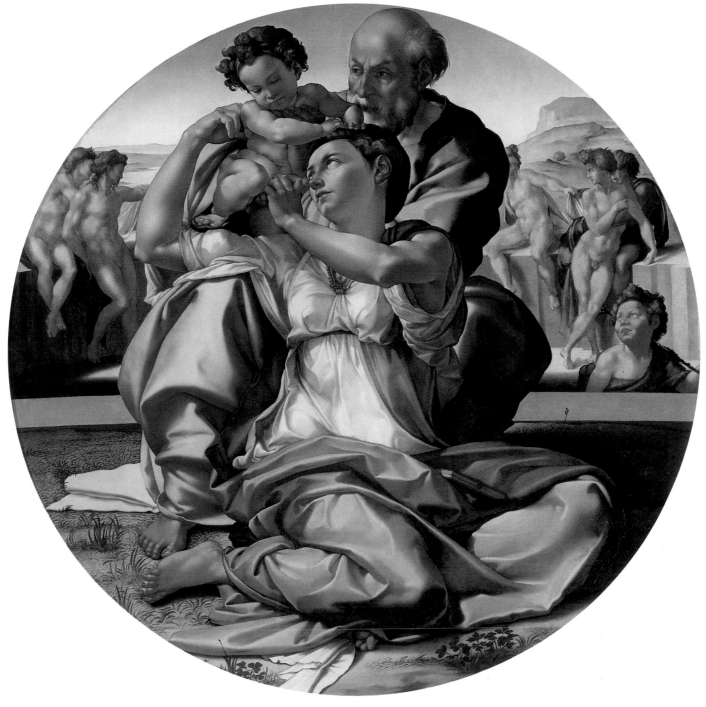

THE MOSES

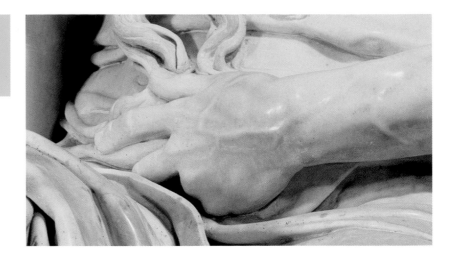

The founder of psychoanalysis, Sigmund Freud, in an essay that became famous (*Der Moses des Michelangelo*, published in 1914 in the review "Imago") was the first to give a plausible, realistic explanation for the posture of Moses, although his reading of the statue was deeply rooted in the concepts of 19th century criticism. Freud hypothesised that Michelangelo had portrayed the patriarch of the Hebrews at the moment when, after having received the Tables of the Ten Commandments, he realised that the people he had guided in the search for the promised land no longer believed in the word of God and had abandoned themselves to idolatry of the golden calf.

The *Book of Exodus* (XXXII, 1-35) narrates in fact that the Hebrews, disheartened and discouraged at Moses' delay in returning from Mount Sinai, asked Aaron, the brother of Moses, to make a new god that would lead them to their goal. When Moses finally descended from the mountain «seeing the calf and the dances, he was overcome with rage and threw down the tables he was holding in his hands [...]. Then he took the calf they had made, threw it into the fire, and crushed it to dust».

According to Freud's interpretation, Michelangelo had chosen the moment in which Moses, after having received the Tables of the Law, realises that his people have betrayed him and is about to rise from his chair. The patriarch must have realised this by chance while, as he was idly stroking his beard, he instinctively turned his head to the left, attracted by a strange uproar: that of the idolatrous Hebrews who, singing and dancing, were adoring the new deity. This unexpected situation would have provoked in Moses first the frown on his face and then the sudden anger that was to thrust him to his feet. Here it should be noted that Michelangelo has sculpted his giant with the left leg drawn back, ready to thrust him forward in great steps toward the field where the Hebrews are celebrating. This sudden, abrupt movement would however have caused the Tables of the Law, which are resting on the cubical seat, to fall. To keep this from happening, Moses presses them against his body with his right arm.

Moses
marble
height 235 cm; 1513.
Rome, San Pietro in Vincoli

THE GIANT IN THE STORM
The critics' judgement of the *Moses* has changed a number of times over the years. Admired by Vasari, «there will never be any modern thing that can rival it in beauty [...] and the same may be said of the ancients», it was a model for artists in the 16th century. The Seventeenth viewed it negatively, as shown by the words of Milizia who called it «inert figure» and «the head of a satyr with the mane of a wild boar», among other things. To this Stendhal, in his *History of Painting in Italy*, seems to reply: «The Moses had an inestimable influence on art [...] the 19th century will undoubtedly restore to it many admirers». And in this he was right.

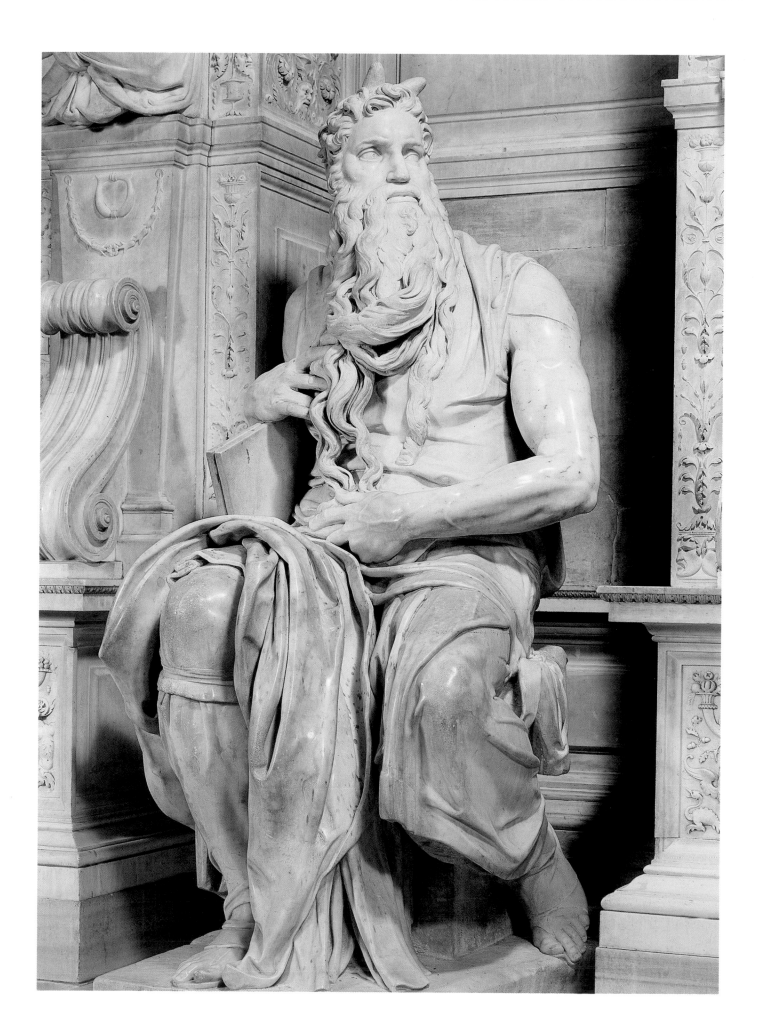

THE NIGHT

《 Dear to me is sleep, and even more to be of stone,/while shame and evil last;/not to see, not to hear is my great fortune;/but do not wake me, speak softly».

With these verses, written in late 1545 and early 1546, Michelangelo replied to the glorifying but affected composition of Giovanni di Carlo Strozzi praising the beauty of the figure of the *Night*, sculpted twenty years earlier for the Medici Tombs. Behind the allusion to "evil" and "shame" lay the resentment felt by Michelangelo for the despotic government of Cosimo I, Duke of Tuscany from 1537 and future Grand Duke from 1569. The artist's interpretation of the statue is the exact opposite of the one proposed by Strozzi, who invited the hypothetical admirer of the *Night* to wake her from her marble slumber.

Michelangelo, instead, saw the statue's condition of eternal sleeper as a great privilege to be viewed with envy. These verses reveal the artist's desire to find himself in the same situation, no longer forced to witness the brutality and dishonour of his age. Better, then, eternal sleep like that of a stone: «a sleep that ends by resembling that of death». «Better to die, then, than to witness the brutality of the world». Even more, continued the artist addressing himself - obviously - to Strozzi: «Be silent with your garrulous chatter that could disturb even the eternal sleep of a stone». But the interesting fact is that Michelangelo was projecting onto the image of the *Night* the quarrelsome attitude of his own inner disquiet, utilising a figure that was born to express something entirely different. He had in fact written earlier that the *Day* and the *Night* symbolised time which consumes all. Condivi reports, in fact, that the artist had considered sculpting the figure of a mouse to accompany the two statues, «since that little animal continuously gnaws and consumes, no different from time that all things devours». And even more, Michelangelo had imagined that the two allegorical figures were saying: «We have with our swift race led to death Duke Giuliano».

Night
marble
lenght 194 cm; 1526-1531.
Florence, San Lorenzo Basilica,
New Sacristy (Medici Chapels)

THE LADY OF QUIET
Worthy of special attention are the elements that accompany the *Night* sculpted by Michelangelo for the tomb of Giuliano II de' Medici, Duke of Nemours. The bunch of poppy bulbs that supports the slightly bent leg of the woman alludes to the oneiric, hallucinatory dimension of the night. The owl, instead, represents darkness, since it is a nocturnal bird. The mask alludes on the one hand to the appearance of things, on the other it suggests nightmarish visions. But the most intimate nature of the figure is that of quiet, of sleep softly lit by the sickle moon and by the star that the artist has sculpted on the diadem.

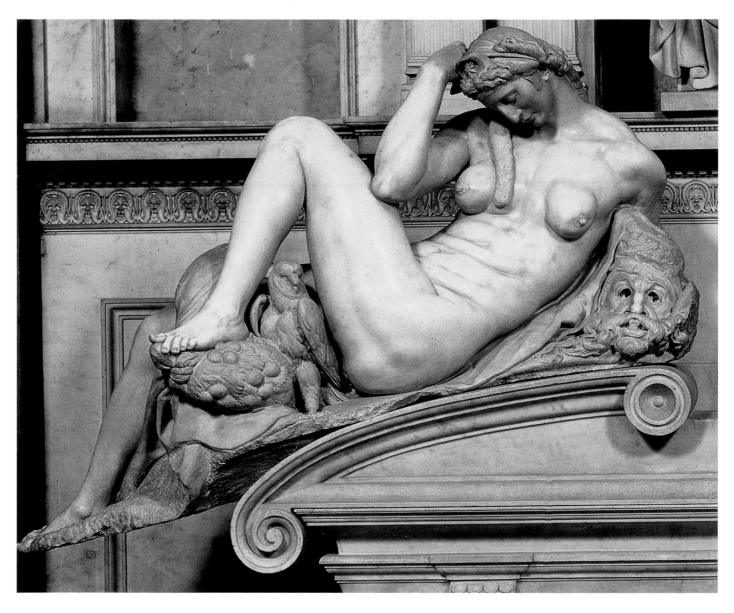

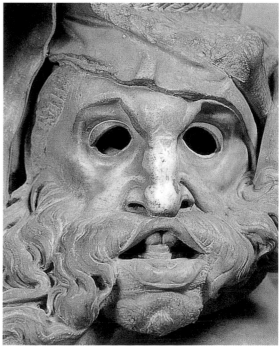

THE LAST JUDGEMENT

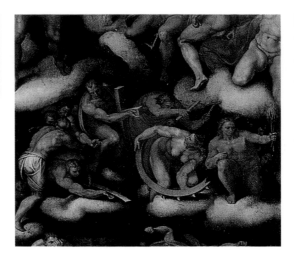

T he enormous wall with the *Last Judgement* frescoed by Michelangelo from 1537 to 1541, during the papacy of Paul III Farnese, is generally considered to represent a true revolution in the manner of depicting this subject.

The impression this work made on the critics, not only those of this century, was highly disconcerting. Stendhal in his *History of Painting in Italy* wrote that, while one nude figure is undoubtedly fascinating, «a group of many nudes has something of disturbing, of crudeness»; a feeling that struck him at his first sight of Michelangelo's wall. It attracts and repels because, as the Belgian critic De Tolnay explained, «the spectator is inevitably overcome by the impression aroused by this vertiginous whirlpool that sucks down into it Cyclopean bodies like impotent dummies». At the eye of the tornado is Christ who, with his gesture, recalls the figure placed by the artist at the apex of his *Battle of the Centaurs*.

Beside him is the Virgin, fearful of the acts of the supreme judge. At the sides, in the foreground among the throng of saints, Peter offers the keys to Christ and John the Baptist wraps himself in a camel's skin.

Immediately below are the figures of St. Lawrence and St. Bartholomew, holding in his hand his own flayed skin in which the features of the artist can be glimpsed. Above are angels bearing the instruments of Christ's Passion. Below at the centre are angels sounding the trumpets of Judgement Day and, lastly, at the bottom flows the River Styx with Charon ferrying the souls of the damned across it.

In reality however, this type of composition had been taken by Michelangelo from the Nordic tradition of the Last Judgement (such as that of Beaune painted by Rogier van der Weyden), known to him through the example of the Pisa Camposanto frescoed by Buffalmacco in around 1336. But what most struck the artists' contemporaries, arousing some scandal, was the presence of those entirely nude titanic figures which, according to Vasari, were no more than a sort of exercise to demonstrate the artist's skill in painting «the perfect and most superbly proportioned composition of the human body».

Last Judgement
fresco
1370 x 1220 cm; 1537-1541.
Vatican City, Sistine Chapel

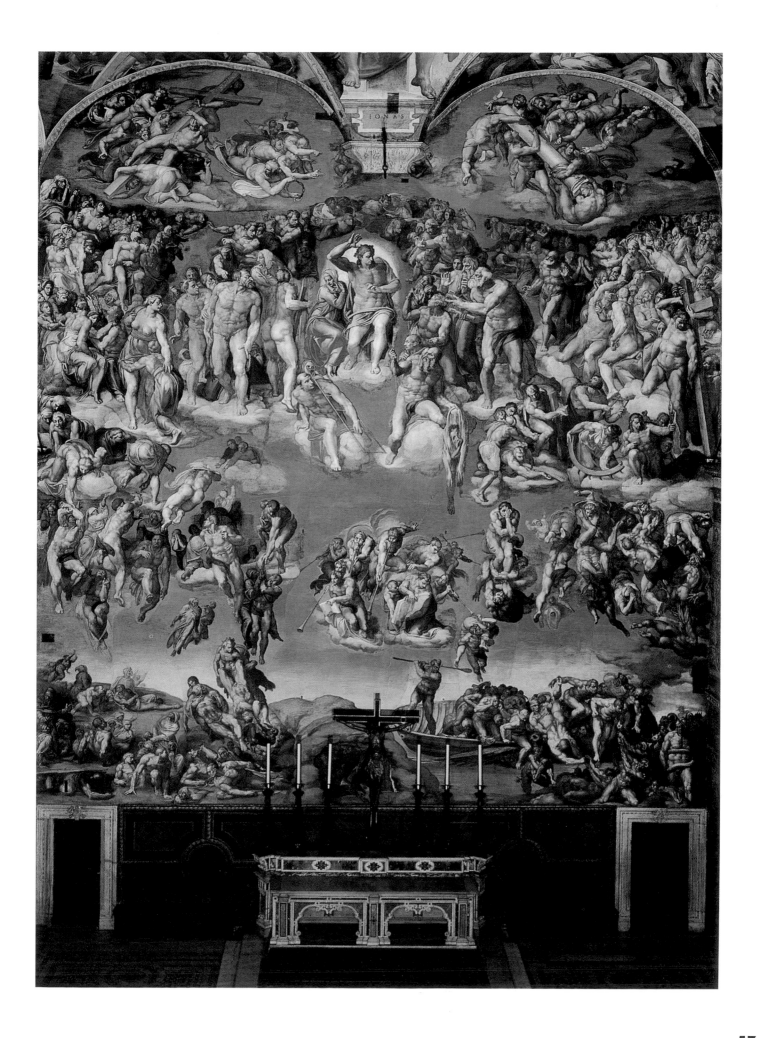

PORTA PIA

Commissioned by Pius IV de' Medici, recently elected to the Papal throne, Porta Pia, designed by Michelangelo between 1560 and 1564, formed part of the program for restoration of the existing gates along the Aurelian walls. Probably for this reason, states Vasari, of the three drawings and projects presented by Michelangelo to the Pope, he «selected to be realised the one of least expense».

Inspired, at least in part, by Medieval constructions as shown by the upper level reminiscent of guardian towers and by the presence of the battlements which have however an ornamental function, the gate reaches its culmination in the vigourous plastics of the doorway. This was the great linguistic innovation of what must be considered the last architectural work of the master, along with the transformation of the Baths of Diocletian into a church, to be called Santa Maria degli Angeli.

In both cases the artist decided to utilise bare bricks, indicative of a return to the building tradition of the Romans, but in Porta Pia the use of this material takes on a martial significance. Moreover, in choosing the architectural order to be employed for the gateway (a preparatory drawing of which can be seen in Casa Buonarroti), Michelangelo utilised, although with modifications, the Doric order considered particularly appropriate for city gates. In the Renaissance tradition, not yet codified, this order was deemed suitable for expressing the concept of pride and power. On the other hand, Michelangelo's use of rustication in the cornice surrounding the true arch, which is retained on the outside by two pilaster strips of travertine (another typically Roman material), is reminiscent of the nearby model of the urban gate par excellence in Rome: Porta Maggiore. It goes without saying that the artist interpreted and even reversed the traditional canons, giving origin to a plastic organism of evocative, capricious forms. The decorative motif of the patens and stoles recalls the surgeon's art, an allusion to the Medici family.

Porta Pia
travertine and brick
3200 x 3500 x 4200 cm; 1560-1564.
Rome

A GATE IN HISTORY
Known for the famous "breaching" of Porta Pia, through which Italian troops entered Rome on September 20, 1870, thus sanctioning the de facto Unification of Italy and the end of the Papal State, the construction has been restored several times over the years. Michelangelo availed himself of the collaboration of Jacopo del Duca for the realisation of the coat-of-arms of Pius and that of Nardo de' Rossi to sculpt the angels beside it. Pius IX entrusted the restoration of the structure to Virginio Vespignani, who worked on it, in several stages, from 1853 to 1864, creating he neo-Baroque prospect opening out on Via Nomentana.

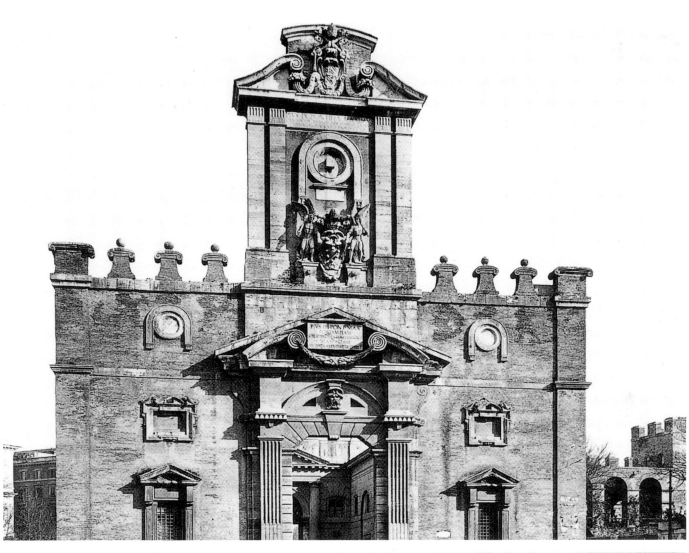

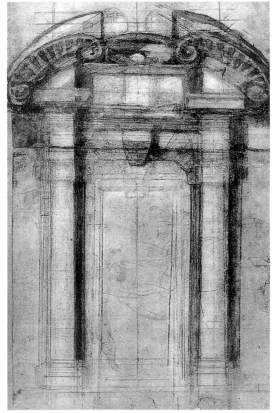

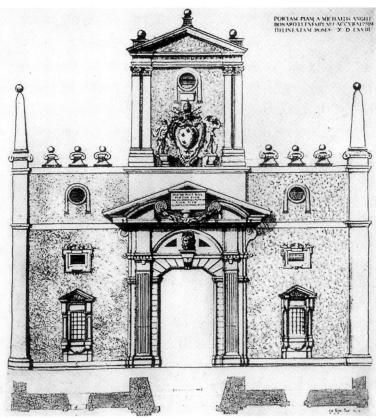

THE RONDANINI PIETÀ

C alled by this name because it stood for some centuries in the courtyard of Palazzo Rondanini in Via del Corso in Rome, this was the master's last work, on which he laboured until that February 17, 1564 when, at the hour of eleven in the night, he breathed his last. There remains, in fact, a description of the work in the inventory of his house in Rome (now destroyed), located near the Church of Santa Maria di Loreto where he went to pray: «Another statue begun for a Christ and another figure above, attached together, roughed out and not finished». This does not mean however that Michelangelo had begun the work in those same years.

The critics, in fact, are agreed in considering that the artist began the sculpture earlier, between 1552 and 1553, at the same time as the *Bandini Pietà*, probably when, already dissatisfied with the latter, he was searching for other schemes of composition. To this first stage in the sculpting of the *Rondanini Pietà* belongs the severed arm of Christ, appearing today as a knotty broken branch to the eye of the beholder. Resuming work on the sculpture between 1554 and the year of his death, the master must have deemed it

necessary to change the position of Christ's arm, whose posture in the first version is reminiscent of that of the *Pietà from Palestrina*. By moving Christ's right arm backward, Michelangelo achieved a more dramatic position for the two figures, emphasising the effort exerted by the Virgin in supporting her Son. In carefully observing the work from the right side, it can be seen how the artist intended to bring the two figures into a single curved line, suggesting the idea of welcoming reception. It is as if the Virgin were giving birth to Christ for the second time, gathering him into her arms after the martyrdom of the cross. This new scheme brought with it, by reflection, the need to shift Mary's face even further to the left.

Although Michelangelo was unable to complete the work, this unavoidable "unfinished" quality provides the most dramatic testimony to the artist's work.

Rondanini Pietà
marble
height 195 cm; 1552-1564.
Milan, Castello Sforzesco

A SPIRITUAL
TESTAMENT
Above,
two details
of a *Study
for a Pietà*
(Oxford,
Ashmolean Museum).
This last work
of Michelangelo,
on which
he laboured
to the last moments
of his life,
can be considered
a true spiritual
last will and
testament.
The shapes are now
bare and dry as if
tormented
by the search
for the best form.
The sculptor,
now an old man,
experiments
with different
solutions expressive
of his feeling of
inner dissatisfaction;
a feeling which
was surely
mingled with that
of a tormented
search for faith.

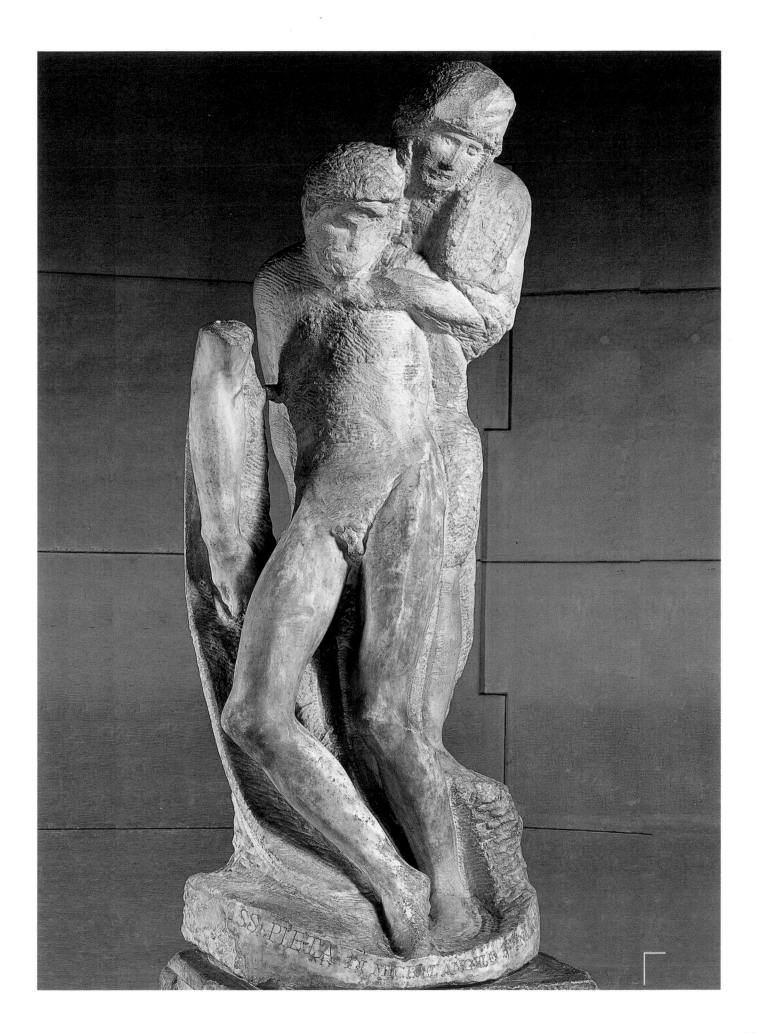

Numbers in bold refer to images.

BIBLIOGRAPHY

Sources: among the various editions of the biographies of Michelangelo written by Giorgio Vasari (1550 and 1568) and by Ascanio Condivi (1553) are: A. Condivi, *Michelangelo. La Vita*, edited by P. D'Ancona, Milan 1928; G. Vasari, *La vita di Michelangelo nelle redazioni del 1550 e 1568*, edited by P. Barocchi, Milan-Napoli 1962; Id., *Le Vite dei più eccellenti pittori, scultori e architetti, nelle redazioni del 1550 e del 1568*, edited by R. Bettarini and P. Barocchi, Florence 1987.

Essays: J. Wilde, *Eine Studie Michelangelos nach der Antike*, in "Mitteilungen des Kunsthistorisches Institutes in Florenz", IV, 1933, pp. 41-64; K. Lanckoronscka, *Antike Elemente im Bacchus Michelangelos*, in "Dawka Sztuka", I, 1938, pp. 182-192; G. Kleiner, *Die Begegnungen Michelangelos mit der Antike*, Berlin 1950, pp. 16-18; F. Kriegbaum, *Michelangiolo und die Antike*, in "Münchner Jahrbuch der bildenden Kunst", III-IV, 1952-1953, pp. 10-36; M. Lisner, *Zu Benedetto da Maiano und Michelangelo*, in "Zeitschrift für Kunstwissenschaft", XII, 1958, pp. 141-156; Id., *Il Crocifisso di Santo Spirito, Atti del convegno di studi michelangioleschi*, Rome 1964, pp. 295-316; E. Battisti, *Storia della critica su Michelangelo*, in G. Grandi, *Atti del convegno di studi michelangioleschi*, Rome 1966, pp. 177-200; Id., *I coperchi delle tombe medicee*, in *Arte in Europa. Studi di storia dell'arte in onore di E. Arslan*, I, 1966, pp. 517-530; Id., *The Meaning of classical Models in the Sculpture of Michelangelo*, in *Stil und Uberlieferung in der Kunst des Abendlandes*, Akten, II, Berlin 1967, pp. 73-78; C. Eisler, *"The Madonna of the Stairs"*, ivi, pp. 115-121; M. Lisner, *Das Quattrocento und Michelangelo*, ivi, pp. 78-89; M. Horster, *Antike Vorstufen zum Florentiner Renaissance Bacchus*, in *Festschrift für Ulrich Middeldorf*, Berlin 1968, pp. 218-224; L. Steinberg, *Michelangelo's Florentine "Pietà": the missing Leg*, in "The Art Bulletin", 50, 1968, pp. 343-353; F. Wildt, *La Pietà Rondanini. Genesi e tecnica*, Milan 1968; M. Easton, *The Taddei Tondo: a frightened Jesus?*, in "Journal of the Warburg and Courtauld Institute", 32, 1969, pp. 391-393; S. Levine, *Tal cosa: "Michelangelo" David. Its Form, Site and political Symbolism*, New York 1969; R. W. Lightbown, *Michelangelo's great Tondo. Its Origins and Settings*, in "Apollo", 89, 1969, pp. 22-31; C. E. Gilbert, *Texts and Contexts of the Medici Chapel*, in "Art Quarterly", XXXI, 1971, pp. 391-409; H. J. Mancusi Ungaro, *Michelangelo: the Bruges Madonna and the Piccolomini Altar*, New Haven-Londra 1971; *L'opera completa di Michelangelo scultore*, edited by U.Baldini, Milan 1973; B. Mantura, *Il primo Cristo della Pietà Rondanini*, in "Bollettino d'Arte", 58, 1973, pp. 199-201; A. Martini, *Osservazioni sul Tondo Taddei*, in "Antichità viva", 12, 1973, pp. 26-31; H. Hibbard, *Michelangelo*, Londra 1975; J. Schulz, *Michelangelo's unfinished Works*, in "The Art Bulletin", 57, 1975, pp. 366-373; F. Hartt, *Michelangelo's three Pietàs*, Londra 1977; A. Luchs, *Michelangelo's Bologna Angel: counterfeiting the Tuscan Duecento*, in "The Burlington Magazine", 120, 1978, pp. 222-225; D. Heikamp, *Scultura e politica. Le statue della Sala Grande di Palazzo Vecchio*, in *Le arti nel principato mediceo*, Florence 1980, pp. 201-251; M. Lisner, *Form und Sinngehalt von Michelangelo's Kentaurenschlacht mit Notizen zu Bertoldo di Giovanni*, in "Mitteilungen des Kunsthistorisches Institut in Florenz", XXIV, 1980, pp. 299-344; H. Hirst, *Michelangelo in Rome: an Altarpiece and the Bacchus*, in "The Burlington Magazine", 123, 1981, pp. 580-593; E. Balas, *Michelangelo's Florentine Slaves and the S. Lorenzo's Facade*, in "The Art Bulletin", LXV, 1983, pp. 665-671; C. Carman, *Michelangelo's Bacchus and the divine Frenzy*, in "Source", 2, 1983, pp. 6-13; R. Liebert, *Michelangelo. A Psychoanalytic Study of his Life and Images*, Yale 1983; F. Verspohl, *Il "David" in Piazza della Signoria a Florence, Michelangelo e Machiavelli*, in "Comunità", 37, 1983, pp. 291-356; K. Weil Garris, *On Pedestals: Michelangelo's "David", Bandinelli's Hercules and Cacus, and the Sculpture of the Piazza della Signoria*, in "Römisches Jahrbuch für Kunstgeschichte", XX, 1983, pp. 377-400; J. Elkins, *Michelangelo and the human Form: his knowledge and Use of Anatomy*, in "The Art Bulletin", 7, 1984, pp. 176-186; M. Bacci, *Le fonti letterarie del Bacco di Michelangelo e il problema del committente*, in "Antichità viva", 24, 1985, pp. 131-134; M. Hirst, *Michelangelo, Carrara and the Marble for the Cardinal's Pietà*, in "The Burlington Magazine", CXXVII, 1985, pp. 154-159; C. H. Smith, *Osservazioni intorno a Il Carteggio di Michelangelo*, in "Rinascimento", XXV, 1985, pp. 4-5 e pp. 8-9; R. Ristori, *L'Aretino, il "David" di Michelangelo e la modestia fiorentina*, ivi, XXVII, 1986, pp. 77-97; K. Weil Garris, *Michelangelo's "Pietà" for the Cappella del Re di Francia*, in *Il se rendit en Italie. Etudes offertes à A. Chastel*, Rome-Paris 1987, pp. 77-119; E. Balas, *Michelangelo's Victory: its Rôle and Significance*, in "Gazette des Beaux-Arts", 113, 1989, pp. 67-80; V. Shrimplin Evangelidis, *Michelangelo and Nicodemism: the Florentine Pietà*, in "The Art Bulletin", XXI, 1989, pp. 58-66; J. Larson, *The Cleaning's of Michelangelo's Taddei Tondo*, in "The Burlington Magazine", CXXXIII, 1991, pp. 844-846; G. Agosti, *Michelangelo e i Lombardi a Roma, attorno al 1500*, in "Studies in the History of Art", 33, 1992, pp. 19-36; F. Hartt, *Michelangelo in Heaven*, in "Artibus et Historiae", 13, 1992, pp. 191-200; E. Pogany Balas, *The Iconography of Michelangelo's Medici's Chapel: a new Hypothesis*, in "Gazette des Beaux-Arts", 120, 1992, pp. 171-126; W. Wallace, *Michelangelo's Roma "Pietà": Altarpiece or Grave Memorial*, in *Verrocchio and Late Quattrocento Italian Sculpture*, Florence 1992, pp. 243-255; J. Beck, A. Paolucci, B. Santi, *Un occhio su Michelangelo*, Bergamo 1993.

Catalogues of exhibitions: G. Agosti, V. Farinella, *Michelangelo e l'arte classica* (Florence, Casa Buonarroti), Florence 1987; *The genius of the Sculptor in Michelangelo's Work* (Montreal, Museum of Fine Arts), Montreal 1992.

PHOTOGRAPHS

Giunti Archives, all of the photographs published except for: Rabatti-Domingie, Florence, pp. 9, 13, 16a, 17, 18, 19, 21, 22, 25, 26, 48, 49, 50, 51, 54, 55; Scala, Florence, pp. 15, 16, 23, 52, 53, 61.
As concerns rights to reproduction: the publisher declares its willingness to settle any charges due for images for which it has been impossible to determine the source. As concerns captions: when not otherwise indicated, the work forms part of a private collection.

Finito di stampare nel mese di giugno 2000
presso Giunti Industrie Grafiche S.p.A.
Stabilimento di Prato